Sc ... **Classroom**

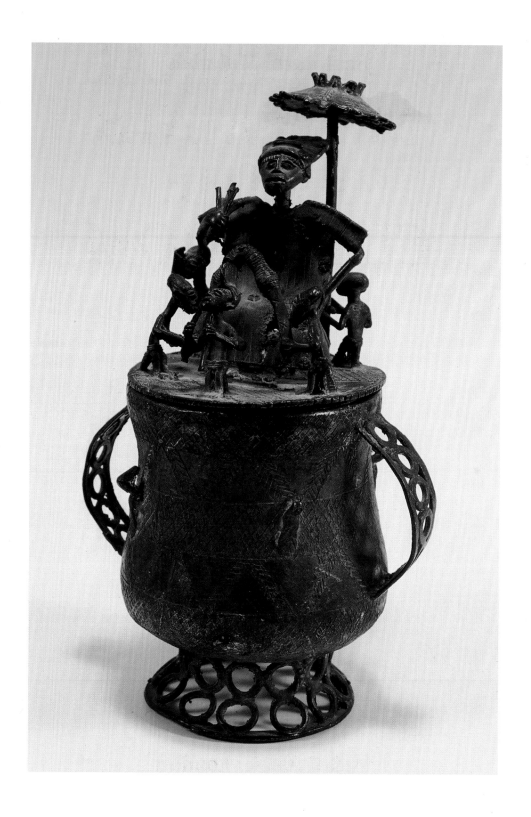

SCULPTURAL MATERIALS IN THE CLASSROOM

Peter Clough

A & C Black · London

To Jen

First published in Great Britain 1998
A & C Black (Publishers) Limited
35 Bedford Row
London WC1R 4JH
Reprinted in 2000
Copyright © 1998 Peter Clough

ISBN 0 7136 4505 9

A CIP catalogue record for this book is available
from the British Library.

Cover illustrations:
Front 'The Iron Man'. Armen, Jason, Claire and
Chris, aged 10-11

Back 'The Iron Woman', Louise, Laura, Natalie
and Ashley, aged 9-11

Frontispiece Ashanti Kaddo, Nigeria, Bronze
(collection of the author)

Designed and typeset by Alan Hamp

Printed and bound in Spain by G.Z. Printek, Bilbao

Contents

Acknowlegements

I would like to thank John Devine, the former headmaster at Bilton Grange County Primary School, his successor, Stef Puchalka, and all the staff at the school for their help, enthusiasm and support throughout this project. I would particularly thank Jen Whiteley who was so constantly generous with her time and energy.

Thanks also to Katie Devine for her assistance with the plaster work. A tribute to the staff at the Yorkshire Sculpture Park in Wakefield is also necessary, for allowing me to photograph there, and for the valuable educational work which they carry out for schools throughout the region. I am grateful to the University College of Ripon and York St. John for supporting me with time to work on this book, and finally thanks must go to all the children for the delight I have had in working with them, and the pleasure and inspiration which their work has given to us all.

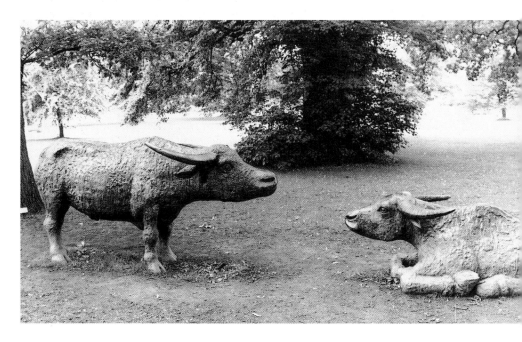

Elizabeth Frink, 'Water Buffalo', Bronze 1988

Introduction

Certainly among the prime impulses of man is the impulse to create objects.
GILLO DORFLES, *The Man-made Object*

The stimulus for this book arose from my experience whilst working with clay with young children for a previous publication. It was apparent that their natural impulse to create objects was a prime and natural response, and that as part of a full and varied educational programme I felt that they should have an opportunity to learn about other materials from direct experience. Hence this book, which is an attempt to introduce teachers and those who work with children up to the age of 11 to a wider range of materials.

In an increasingly technological society dominated by mass production we tend to take for granted both the means of production and the forms of that production. That is the world which our young children now grow up in, and for them to begin to develop insights into this made environment it is imperative that they are given an opportunity from an early age to acquire the skills which they need to understand it. These include manipulative skills, visual and spatial awareness, critical analysis and discrimination, and an ability to solve problems in an individual way. Above all they should experience the joy and satisfaction of simply making.

The emphasis in this book, and in the work which the children have made has therefore been to try to strike a balance between all these skills, whilst still retaining and encouraging an individual creative response within both the work and the wider curriculum.

The materials covered in this book are those which should be readily available for such work with this age range, and for teachers who may feel unsure about using them I have tried to suggest simple, practical ways in which the teaching may, for the most part, be effectively accomplished in an average classroom.

Finally, just try it. The excitement of learning together, and the pleasure and involvement of the children is, as I have found, full educational justification for this business of making, and well worth the effort.

Harrogate 1998

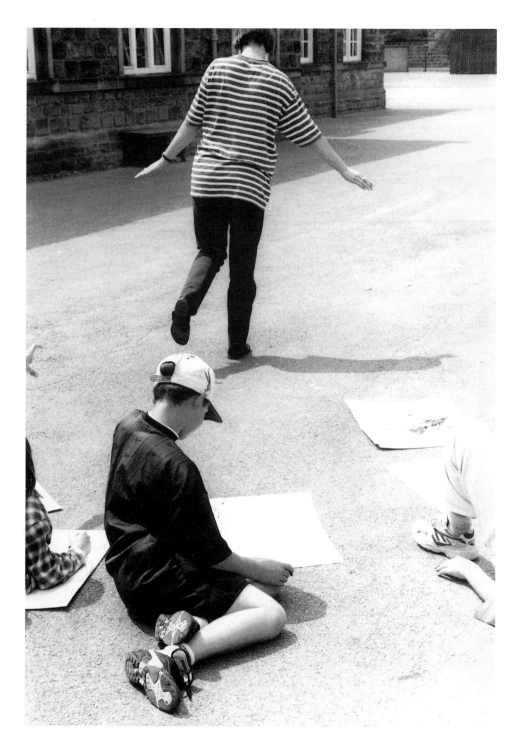

Children drawing a moving figure.

Chapter One
The Three-Dimensional Experience

For a whole host of obvious reasons much of the work which children up to the age of 11 and beyond undertake in school is centred around two dimensions. They work from books, and carry out activities in most areas of the curriculum working on flat sheets of paper. Even in art there tends to be a preponderance in many classrooms with working flat through drawing and painting. Given the complexity and range of learning which we now require teachers to deal with in what is often an increasingly limited timescale this scenario is almost inevitable.

It is not the purpose of this book to suggest that this balance is wrong, but perhaps in a small way to suggest that with a slight change in emphasis towards making where it is not already being done, we can widen, deepen and enrich the learning process for our children. In so doing, there is I believe, enormous scope for links across the curriculum, and for beginning to develop a range of individual skills and insights of real relevance in our increasingly technological society.

People as makers

From prehistoric times to the present day people have taken materials and fashioned them to provide objects which satisfy a practical or spiritual need. Each culture has acquired and built upon this experience of working materials in dif-ferent ways and passed on to following generations that knowledge and skill.

The sheer diversity and range of this output is in evidence in our museums, galleries, and also around us everyday, and is a reflection of our own and other societies and cultures, and helps to give us our sense of time and place. Our children, as part of their general education, and growing self awareness and personal identity need, I believe, to be made aware of this heritage. We can achieve this in a variety of ways at different levels and through different experiences. By far the most important, in my view, is through direct experience.

By presenting the children with objects and artefacts in the classroom, or on outings, they are able to touch, hold and respond to things in an intimate and personal way which is rich and meaningful. They can be encouraged to relate this experience to other areas of their knowledge and the curriculum, and to build links which reinforce their awareness of themselves and their surroundings.

An important element in this process is the development of an understanding about how things are made, and the visual differences between objects which are hand made and those which are machine made. Linked to this are the differences in the ways in which materials are worked, with perhaps the mark of the maker on the individual unique object, and the anonymity in those

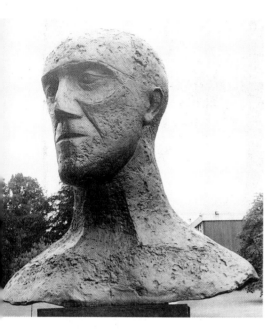

Elizabeth Frink, 'In Memorium', Bronze

Sculpture as an art form

It is perhaps appropriate at this point to give some thought to the differences between sculpture as an art form, and the other areas of the visual arts, particularly in relation to our work with children. Given as I have suggested, the preponderance of two-dimensional work normally undertaken with this age range, it is inevitable that children's visual development and understanding are likely to be more acute in terms of shape, colour, line, pattern etc. than they will be in relation to form, space, surface etc. which are those aspects of the language of art of particular relevance to three-dimensional work.

Form and space

Three-dimensional objects exist in space. They are surrounded by it, they contain it, and it may go through them. We tend to be more visually aware of the form of an object, the positive element, than of its surrounding space, which could be considered the negative. After all, you can't actually see space and this is a difficult visual concept for children to understand. There is no doubt in my experience that children tend to work with the positive elements of form for the most part. This is not to say that they cannot appreciate space. They are made aware of it at a personal level in terms of body space in other areas of the curriculum, notably dance and games.

When they begin to make forms in any material, a range of visual decisions and insights have to be considered. These include the proportions of the various elements, the balance, and whether it is a strong form or a softer, weaker one.

Their visual education is predomi-

which are mass produced. As adults, we perhaps tend to take these qualities for granted, but these are concepts and insights which need to be pointed out to young children, and of course all good teachers will try to do this as a matter of good practice.

When looking at three-dimensional work with our children, we need to make them aware of the differences between art and design. Designed objects are essentially concerned with solving a perceived practical and functional need, whether it be a building, table, chair or toothbrush. Art objects are an expression by the artist of his/her concerns, feelings, ideas and the function here resides in the communication and expression of these to an audience. It is this latter area which is the focus of the work in this book, although there are inevitably overlaps which occur, depending upon the initial stimulus which was given to the children.

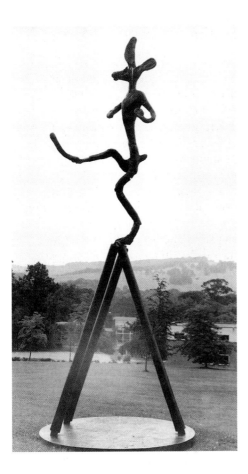

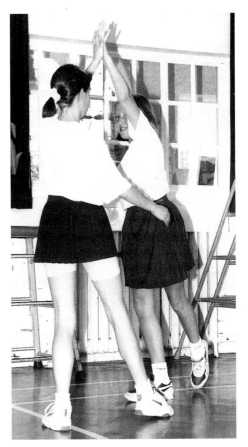

Above
Barry Flannagan, 'Cricketer', Bronze 1989

Right
Children dancing, exploring space and movement.

nantly centred around two-dimensional images, and they are bombarded with these daily through television and other media so their understanding and ability to respond to them becomes quite acute. This tends, in my experience, not to be so with three-dimensional forms. They have less experience of them, and their visual judgements are often less critical. All the more reason then to engage them in this work.

Surface

Here we are considering the surface qualities of the form, and it will often depend upon the properties of the material being used. Surfaces can range from smooth to heavily textured, to those which are hard or soft, shiny or matt, coloured or plain.

The types of surface which the children give to their work will inevitably depend to some extent upon their previous experience of what can be achieved with different materials, the subject matter which they are dealing with, and through encouragement by the teacher to experiment with new methods and approaches.

11

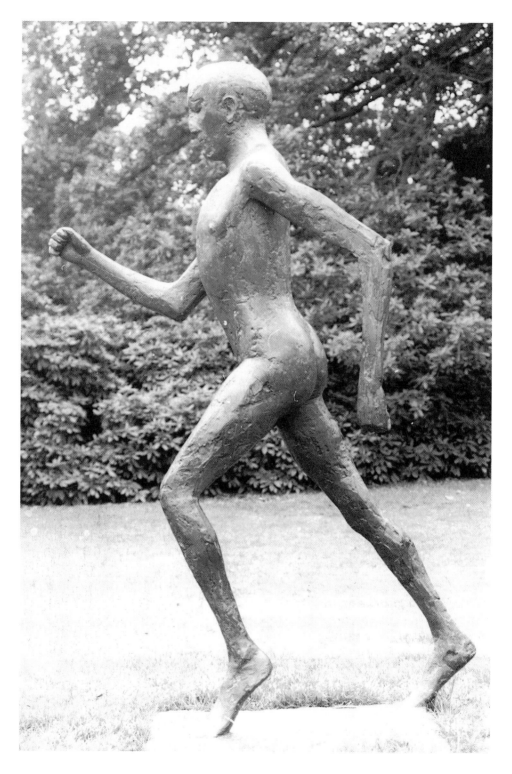

The important educational experience here is not just the visual quality, but also the tactile. Children should be encouraged to use all their senses when they are working, and the sense of touch is central to their physical engagement with materials.

Naturally, they may well have begun to develop this personal awareness of surface qualities through work in other art activities, such as collage and printmaking.

Mass and weight

The mass and weight of an object give it particular qualities. These can include, for example, a physical presence, possibly a sense of permanence, and the potential for physical interaction by the viewer, which is not the case with a painting or drawing. There is also that particular relationship between the apparent visual weight of an object, and the actual physical weight. These can be confusing sometimes, and children do get excited when, for example, something which looks very heavy actually turns out to be as light as a feather.

Scale

Scale is important. Because very young children are themselves small, there is a tendency to think that they are likely to work on a small scale. This need not be the case and it is perfectly possible to devise projects which encourage them to think on a large scale. Naturally as they

become older, develop more skills and are able to work in groups as teams, the possibility of larger projects becomes more obvious. There are examples of such work later in the book. Making work as big as themselves is both exciting and challenging, and the learning which takes place in group interactions, and the collective solving of problems is particularly valuable. Naturally, careful planning has to be undertaken by the teacher, and the material to be used has to be appropriate, but it can be achieved relatively easily with a bit of effort and thought, and I have found that even

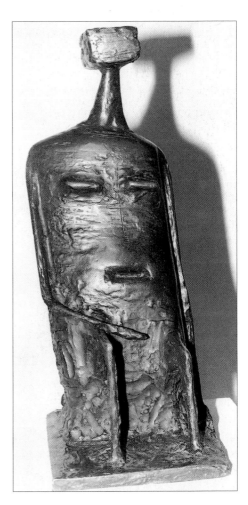

Left
Elizabeth Frink, 'Running man', Bronze 1978

Right
Kenneth Armitage, 'Seated woman with square head', Bronze 1955

13

very young children will rise to a challenge if they feel it is attainable and are given the right encouragement.

Cross-curricular links and issues

These are many and various, and it is not possible in the context of this book to consider them all. However, there are some interesting issues relative to Art and Craft, and Design Technology work, particularly as we are using some materials which are common to each. There are differences in both approaches to the work and the outcomes in these areas.

In design we are defining a problem, suggesting solutions, selecting what we think is the best, making a prototype, testing it and evaluating the result.

In art we are encouraging an approach which starts with a response to a stimulus or an idea, and which then involves making an artefact, be it a painting, drawing, clay model, etc. which will develop and change through the process of production. These changes and modifications may be the result of a subjective, aesthetic decision, or by a response to a practical problem encountered with the medium, or by a combination of both. It is very much a process of learning by doing. The end product may lead onto another piece of work, and this process of evaluation and critical involvement is ongoing. The children learn to take possession of their understanding of ideas and materials, and use it when they are next confronted by a similar situation. Whilst there will be times when the children will be engaged in art activities for their own sake, it is more likely that the work will be part of a cross-curricular topic or

Drawings for clay modelling by children aged 10-11

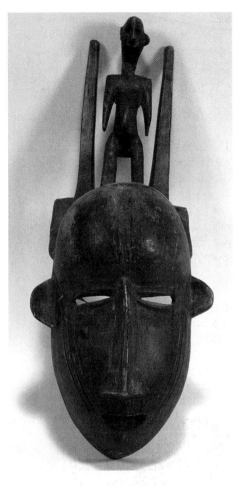

Above
Kenneth Armitage, 'Diarchy', Bronze 1957

Right
African mask from the Cameroons, Wood
(collection of the author)

theme. In relation to the sculptural uses
of the materials covered in this book,
some of these curriculum links are
worth mentioning.

Science

There are a number of scientific
concepts which can be introduced and
explored when working with these
materials. With both clay and plaster the
principle of change, both reversible and
irreversible, is an obvious one. Clay can
be taken through the process of soaking,
drying and soaking (reversible) and
firing (irreversible). When mixed to a
saturated solution with water, plaster
sets hard by recrystallising, which is
irreversible. There is also the concept
that materials can be changed in shape
by applying forces such as bending,
squeezing, rolling, carving, and so on.
Children also learn to differentiate and
group materials by their properties, i.e.
shininess, hardness, smoothness,
strength, and by their everyday uses.
The processes which we use to work
materials, such as heating clay, or taking
moulds, can be related to the ways in
which we manufacture glass and metals,
or cook food. The African masks initially
began from concepts of ways negative

moulds are used to produce forms in plastic and metal, and developed on from there by taking plaster casts from clay.

Whilst providing much material of scientific value, the study of human organisms, animals and plants, is also an important resource for the visual and creative development of young children and is relatively easy to bring into the classroom to provide first hand stimulus. There are examples of this in later chapters.

History

As I have mentioned earlier, it is through the study of archaeological and artistic remains and artefacts in a whole range of materials that we all develop an appreciation of the heritage of our own and other cultures. They allow an insight into the domestic lives and spiritual attitudes of earlier generations, and the artefacts produced from prehistory to the present day provide us with a rich seam of material to which children may respond. There are examples of some of these starting points later in the book, where stimuli as varied as Nordic legends, African art and twentieth century sculpture have been studied and used by the children. Obviously, it is for each individual teacher to select, present and discuss the material which is appropriate to the particular topic to enhance the breadth of learning for the children.

Mathematics

This is an implicit area in any practical activity. The process of making and using materials often requires measuring length, areas and possibly estimating volumes, and the demands which the particular activity makes will inevitably vary with the circumstances at the time.

Relative weights of different materials can be explored and charted, and when using clay the changes in weight and size from plastic to dry and on to the fired state can be measured.

Language

Language provides an essential tool for the development of the creative process in art. The wide range of stimulus which we present to children in this area gives a variety of contexts for the development of a verbal response, demanding an extended vocabulary to express their ideas and feelings, and the use of tools and media. As they work and develop their ideas, and begin to evaluate both their own and others' work so language can enhance this articulation and exchange.

There is much potential for exploration of the inter-relationships between language and art. Language itself through a poem or story might provide the basis for an art activity, and images and artefacts themselves might provide the focus for discussion and writing.

The teacher's role

The balance between imagination and skills
When presenting work to children there is a fine line to be drawn between these elements as every teacher will know, and it is a line which will vary depending upon the sort of learning and experience which the teacher decides should take place. At one extreme the children may simply be given the material and asked to play with it, making whatever they wish. This is a perfectly valid imaginative approach. Children will begin to work, using whatever previous experience they have in

terms of handling and forming, discovering for themselves what the material will do and how it behaves, how it can be joined and formed, and as part of a group experience, looking at what other children are making. They will generally rely on their own ideas about what they are producing, although they may also take on ideas from others in the group. Many of the small clay modelled pieces made by younger children in this book were produced in this way. At the other extreme there is the totally teacher-centred approach which relies on carefully followed technical instruction, resulting in work which has a minimal imaginative input from the child, and which may remain lifeless and dull.

Fortunately, this latter approach is rare, but there is still a need to teach children the skills to enable them to use particular materials easily and efficiently to make what they wish, and to understand in advance where the problems are likely to occur. Later chapters which deal with particular materials suggest some of these problems, and the ways in which they may be dealt with. Given that some teachers may themselves be unfamiliar with the working properties of particular materials they are offered as guideline in planning the work. I firmly believe that whilst with some materials, notably clay, an open-ended exploratory approach by the children is valid, the more resistant and unfamiliar the materials become, the more important it is to spend time teaching the necessary skills. If this is not done, there is a real danger of both frustration for the children and poorly made work with an unsatisfactory end product. For this to happen, there needs to be a sequential programme of experience throughout the primary years which

relates to the physical and intellectual development of the child and provides a basis for the progression and development of skills and understanding.

The ways in which children are taught skills are very important. If they are given widely spaced and random experience in the use of any material, many children have difficulty in retaining, and then recalling and building upon it. It is important that once they are presented, skills are practised, and the knowledge consolidated, particularly with those who have difficulty in approaching and retaining new ideas and concepts in the first place. In addition, the sequence of three-dimensional activities should be so structured that problems encountered in one project are re-inforced and developed subsequently, and that skills learnt in one material are able to be transferred and used in another.

These skills might group themselves under simple headings. For example, ways in which materials are joined, clay with slip, wood and card with glues. Or the ways they are cut: clay with a wire or knife; card with scissors, and wood with a saw.

Session planning

For the teacher any session should consider where the emphasis will lie, and what the content will be. There are, however, times when we underestimate children's ability. To set a challenge to children, as I have done, and to see them rise to it is very rewarding. If they have problems, some support from the teacher will often see them through.

This said, the following questions are provided as a focus for this thinking and assuming that the children's stage of development and previous experience is known.

Above
Shelley aged 9, 'Lady in a chair', Terracotta

Below
Drawing natural forms before modelling.

1. What stimulus is going to be used for the work? What story, object, topic etc. will be presented to the children to focus their thinking?
2. What are the links between this stimulus and other areas of the curriculum?
3. What new insights are going to be introduced about a particular material?
4. What new skills or processes are going to be demonstrated /explained?
5. How will you relate the stimulus to the process, and what freedom will you give the children to develop their ideas in an imaginative and personal way?
6. Will you involve the children in a problem of visual and /or practical nature, which they will need to solve?
7. How will you organise the practical work to ensure that the work can be accomplished in an efficient way, and

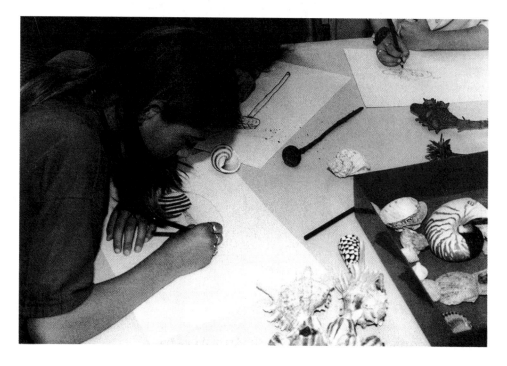

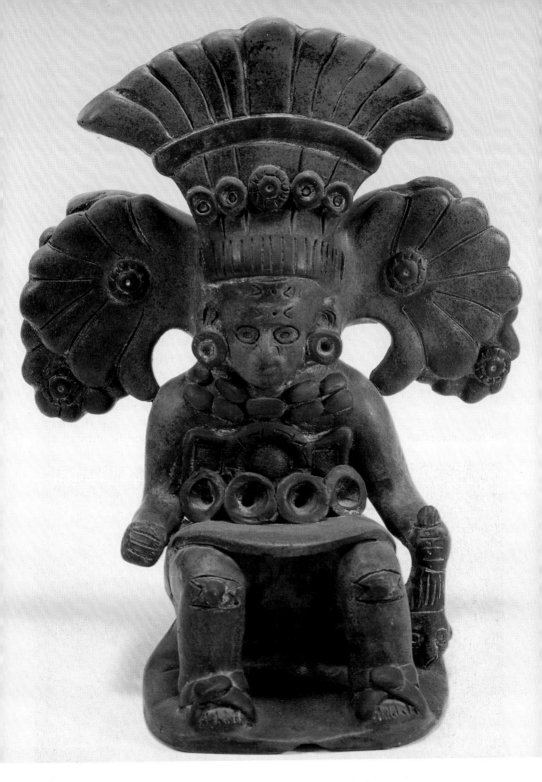

Pre-Columbian Mayan figure from Mexico (collection of the author)

with an economical use of time?

These are the major basic theoretical planning issues which need to be addressed, the questions about classroom organisation and ways in which materials can be used are covered in more detail later, but it is important to mention that it is useful for a teacher, who is unfamiliar with a process or technique, to spend a little time practising it before a session to instil the necessary confidence.

Starting points for work

The selection of particular topics or subjects for three-dimensional work will obviously depend very often on the general curricular theme which is being followed.

However, there are so many possibilities for using different subjects with different materials, aside from those occasions when we just engage in creative activity for its own sake, that the potential is almost endless. The examples in this book are only a few of the ways in which we can extend our work with children.

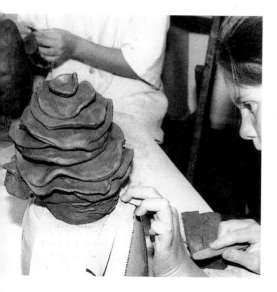

The following are some of the themes or starting points which you might like to consider, but of course they are only offered as suggestions. It has to be for the individual teacher to decide where the enthusiasms and the needs of the children will be directed.

The human form

The human form has been used as a subject by sculptors since prehistoric times, and interpreted in a variety of ways, using whatever materials were available. Children similarly, from an early age, readily use images and models of themselves, their friends and family in their artwork. It provides a means of externalising their environment, telling stories about events which have happened to them, and assisting in developing a sense of personal identity. Much work in this book reflects these concerns with representations of the human form. They can be approached as single figures in particular situations – sitting, lying down, dancing etc. or as groups of figures. Parts of figures also provide good subjects, particularly heads, and can be approached in a figurative or abstract way.

There is also the important element in these subjects of the children being able to work from each other, to work out poses, or to look closely at proportions etc., all part of a direct experience approach. Some work in this book was developed by the children from photographs of themselves dancing and moving, which they found very exciting.

Left
Modelling a seed pod form in clay.

Right
Tropical seed pod.

The natural world

There is so much for the children to explore in this area in terms of both the visual qualities, and in understanding how it is formed that thepossibilities are endless. We can divide this whole subject into the two broad categories of natural forms and animals. Of particular significance to the children is their consideration not only of the ways things such as seed pods, shells, plant forms and rock structures are formed and what they look like, but also being aware of the function which often underlies their external appearances. The delight and curiosity of the children when exploring new and unfamiliar natural forms, holding and turning them around, perhaps looking inside, is a fine way of developing their three-dimensional awareness.

There is similar enthusiasm when they are asked to respond to the animal world. Here the range from domestic pets to farm and wild animals, and the rich variety of the insect world all provide potential subjects for exploration through making. Examples of these responses occur elsewhere with suggestions as to how they might be approached in a practical way.

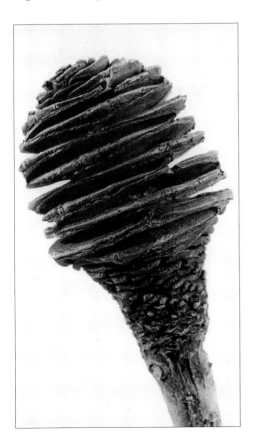

Responding to the work of artists and other cultures

It is important that children are encouraged to look and respond to the work of other artists. They need to be aware of the huge diversity of activity in the visual arts, not just in contemporary terms but also within the historical context. This awareness might be used as a starting point for their own activity, or it might be used as a cross reference to widen their awareness of possibilities within a particular session. However it may be introduced, it is important to remember that it is not there just to widen the children's experience, important though that is, but also to enable them to develop and deepen a critical and evaluative response. In this, it is essential to question the children and challenge their thinking, questions such as – what materials have been used in this work? What words could we use to describe this form? How would you describe the way the artist has used shapes, textures, colours? When do you think this was made? etc.

There are examples elsewhere in the book of children's responses which have developed from looking at other artists' work.

Stories

With this emphasis on responding to things which can be seen, it is important to remember that there are other stimuli which rely on encouraging the imagination and some fine work can be achieved from a story or poem which lends itself to a strong visual response. In this book there are two examples of this approach: some relief panels based on the story of Beowulf, and the Iron Man and the Iron Woman, based on the books by Ted Hughes. The important thing here is to select a story or subject which is rich in visual language imagery to enable the children to build a strong mind picture before they start. I have found that a session of preliminary drawing was often valuable in allowing the children to clarify their ideas before facing the problem of working in unfamiliar materials.

Health and safety

The variety of materials outlined in this book are those which tend to be readily available in most schools. Teachers should be aware of the likely issues of health and safety which will affect working with them – factors such as minimising dust when working with clay and plaster, working with tools in a safe way, and so on. There are detailed practical suggestions later under specific materials which point out some of the problems of working with unfamiliar tools and materials, but provided sensible precautions are taken and the activity is given enough space and direction there are likely to be few problems in achieving this work.

Classroom organisation

Aside from some clay activities, most of the work produced in this book was achieved with groups of around 6-12 pupils, sometimes working individually, and sometimes working in groups of 2-4 on a joint project. This is not to say that with good organisation and resourcing whole class activities are not possible, but for certain types of work, particularly the large-scale plaster work, it would have been impractical in terms of space to try this with a class of 30 or so pupils. There is much to be gained in my experience in terms of group creative interaction and learning from setting children a task to solve and create together.

Clay, wood, card and wire pose little practical difficulties when used in a normal classroom, and plaster bandage work, if properly organised can be controlled well, even with very young children. The larger plaster pieces will need a separate area in the school, simply because of the potential for making a mess, and in my case they were made in a room set aside for the more messy art and craft activities.

The following chapters cover the properties and uses of a variety of materials, with more specific information at the end of each chapter, describing some of the projects undertaken with children across the age range.

Chapter Two
Clay as a Sculptural Material

Of all the materials commonly offered by teachers to young children for three-dimensional work, clay tends to be the most popular. Children of all ages respond quickly to the ease with which it can be formed, changed and joined, and to the wonderful tactile qualities which are inherent in this material. Its malleability encourages and almost demands an imaginative and creative response, but as with most apparently easy materials there are a whole range of properties and problems which the children need to learn about to exploit in full its creative potential. Basic handling methods are detailed later in this chapter, but within the area of sculpture there are a variety of traditional and historical applications of clay both as a principal medium, and also as a transitional stage to a final form in another material, e.g. bronze, concrete, plastic etc.

For the most part, work with our age range will be mainly centred around basic modelling and construction methods, and with the final work either allowed to dry to a hard, unfired state, or

Modelling a large head.

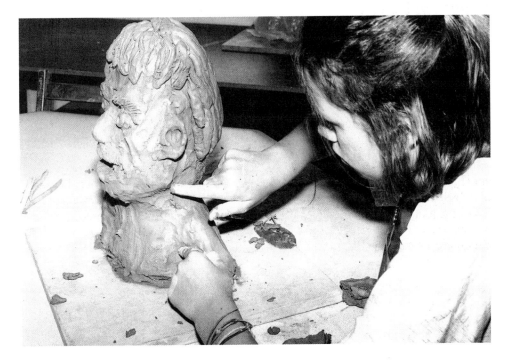

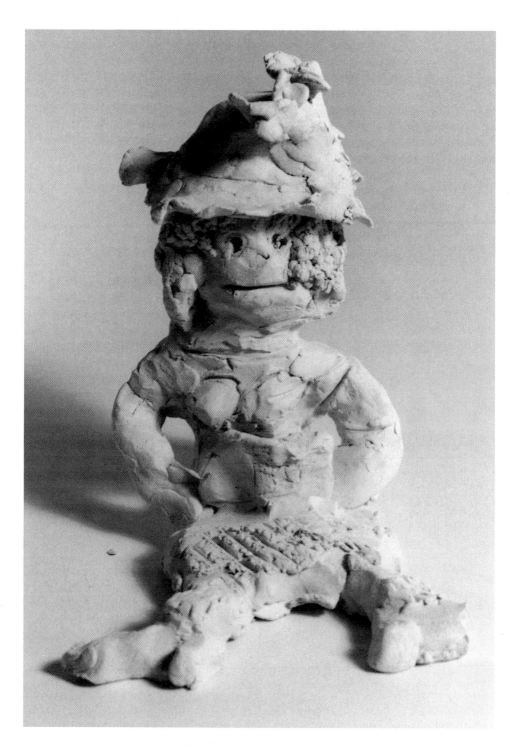

Francis, aged 8, 'Lady with a hat and book', Biscuit fired clay

if a kiln is available, to the permanent biscuit and/ or glazed stage.

The intrinsic malleability of clay as a material, its flexibility and potential for alteration and change have endeared it to sculptors for centuries. It is a medium which allows for an open-ended development and expression of ideas on a variety of scales, from tiny hand-held works to pieces which are over life-size.

In this chapter, I will be considering the use of clay under two headings: as a final form for firing, and as part of a moulding process for translation into another material.

Before that however, it is essential that we consider some of the physical properties of the material itself, and the implications of these for our work with young children.

What clay is made from

Children are innately curious, and you are bound to be asked where clay comes from, and what it is made from. The fact that there might be clay underneath the school is something which could be pointed out, since clay in one form or another covers much of the earth's surface. How it is formed, and an understanding of the different qualities of clay, requires more careful explanation, but in essence, all clay originates as either igneous or metamorphic rock, which is then broken down by water and ice to form clays with different characteristics. They can be either Primary or Secondary clays. Primary clays are found where they are formed and tend to be very pure and white or cream in colour, whereas secondary clays are transported by ice and water and then deposited elsewhere. This process results in finer clay particles in secondary clays which make them more plastic, and

produces a variety of colours from light grey to a deep red, depending on the iron and other impurities which are picked up during transportation.

Some of these deposits can be used for making sculpture with little further work, but often they require blending with other clays and minerals to render them suitable for particular making or firing processes. When this is done they are called 'bodies', and the educational suppliers catalogues contain many different clays for use in a wide variety of situations. We will consider the selection of the most suitable clay later. Before we do this, some explanation of the structure of clay bodies is useful, because this has a fundamental effect on how successful the children will be when they are working with it.

I have mentioned plasticity already, but the strength and plasticity of a particular clay is extremely important in determining the way in which it will work. The finer the particle size, the more plastic it will be. China clay and some fireclays have a coarse particle size, and are therefore very 'short' or 'lean' with low plasticity. The secondary clays – ball clay, some fireclays, and earthenware clays – are often already very fine and plastic, and are called 'fat' or 'long' clays.

The differences in these clays are due to the crystal structure, and since this has such profound influence on the working properties it is necessary to understand a little of this for our work with children.

Clay is made up of microscopic flat and roughly hexagonal crystals which are smallest in ball clay and secondary clays, and largest in china clay. Even so, the smallest speck of clay dust will be made up of many hundreds of crystals, and these are invisible to the naked eye.

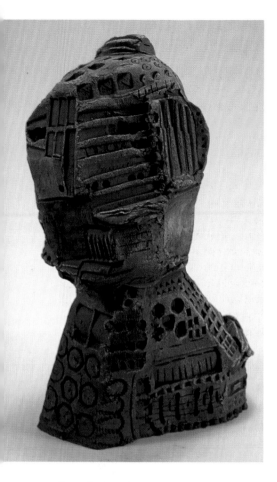

Paul, aged 10, 'Robot Head'

In between these particles is water, which acts as a lubricant and allows them to slide over each other. As the water evaporates the clay crystals come closer together and the clay becomes harder and more brittle, eventually cracking when worked. In practical terms it is important that the clay retains this water content for as long as possible when children are working, and both the teacher and children must be alert to this as a problem. Suggestions for controlling the moisture content of clay occur in later chapters.

The stages through which clay goes during drying are – plastic, to leatherhard, to greenware, and bone dry. Leatherhard is the state when the clay is firm enough to be picked up without bending, when the crystals are just touching, and when the clay will take a polish with a smooth tool. Greenware is the state when the clay has been allowed to dry out completely ready for firing. There will still be a small amount of moisture retained in the pores of the clay, but no further work can be done to the form, which is now hard, but very brittle. The bone dry state occurs during the early part of the firing cycle when the clay reaches 100°C (212°F) and the atmospheric moisture retained in the clay is driven off. Almost all of the work which we do with children occurs when the clay is plastic or soft leatherhard, and this is the time when moisture loss is most rapid.

During the drying and firing process all clays shrink. Most of this shrinkage occurs up to the greenware stage, when a clay might shrink between 5%-8%, with further shrinkage during the firing giving a total shrinkage from start to finish of between 11%-13%. This does not usually cause too many problems with children, unless a very dense clay which has a thick section is allowed to dry out quickly, which can lead to drying cracks. Before we can decide on the selection of the most suitable clay for our classroom work, we need to consider the general categories of clay types, which for most practical considerations in school divide into either earthenware or stoneware.

Earthenware

This is the most common clay, and the one most likely to be found in the locality of any school. It is usually reddish-

brown, although it may also have a yellow ochre or black-brown colour, depending upon the amount and type of iron contamination. It is a dense clay, very plastic, and remains porous when fired which means that it requires a glaze all over if it is to hold liquid. The lower glaze firing temperature of between 1060°C (1940°F) and 1140°C (2048°F) permits a wide range of colour in the glaze, which normally has a good bright shiny surface.

There are many examples in our museums and art galleries of early work in this clay. It is sometimes called terra-cotta when it is unglazed, and because it requires a low temperature firing, often in very primitive kilns, it has been used by societies and cultures around the world from earliest times both for domestic pottery and sculptures.

Stoneware

This is usually a grey or buff colour in the natural state, and will fire to a much higher temperature than earthenware, between 1200°C (2192°F) and 1300°C (2372°F). This higher temperature produces a very hard and strong product, which is often vitrified, and which because it has a low porosity will hold liquids.

In a glaze firing the body and the glaze mature at the same time, forming a body-glaze layer which gives a distinctive soft and mottled appearance to the glaze surface. The colours also tend to be more muted and earthy, with browns, greens, ochres and blacks predominating, although recent developments in ceramic technology have increased the palette of colours available.

Ashley, aged 10, 'Head of an old man', Stoneware

Selecting the right clay for your children

It is absolutely essential that the clay which you give to the children is the right one for the work which they are going to do. There are five questions which you need to ask and answer as a teacher:

1. What type of clay am I going to use, Earthenware or Stoneware?
In terms of working properties there is likely to be little to choose between these two clays, but if you require the warm red colour of earthenware then this will be an obvious choice. It is useful to have available both clays, because older children may have individual preferences when it comes to selecting the material to realise their ideas.

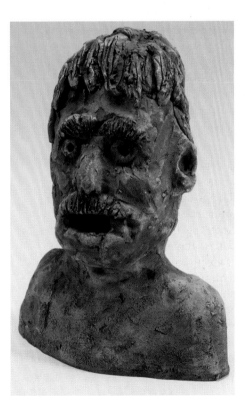

2. What state is the clay in?

This is of paramount importance for success. The teacher needs to develop an instinctive feel when handling the clay for what it will allow the children to make. The clay must be neither too sticky nor too firm. It is preferable in a warm classroom for the clay to be a little too soft to begin with, as it will begin to firm up within half an hour as it starts to dry. If it is too firm, then the clay will be more difficult to work, and will begin to crack before the children have finished.

3. What are we going to make, and how big?

The texture of the clay is vital here. If you are making small modelled forms with fine detail then a smooth clay is likely to be satisfactory, but if you are intending to make forms with a thick section involving heavy modelling, and require a rough or textured surface then you must use a clay which contains sand or grog (ground fireclay) to assist in supporting the structure and allowing it to dry evenly without cracking.

4. Is it going to be fired?

If the work is intended for subsequent firing then the practical considerations of likely firing temperature and the thickness of the work will need to be borne in mind during the making process.

5. Is it going to be used to take a cast?

If the clay form is going to be used as part of a moulding process, probably in conjunction with Plaster of Paris, then the texture of the clay is important. A fine clay will allow good reproduction of detail, as well as easier release of the clay from the plaster mould. A heavily grogged clay makes this more difficult and there may well be some loss of detail in the cast due to the grogged surface.

Classroom organisation

There appears to be a general acceptance amongst teachers of my acquaintance that clay is an important experience for children to have, but this is tempered by worries about the mess that it could create, or with their own lack of experience in using it.

If you are lucky, you may already be working in a situation where clay is used on a regular basis. There will be materials and tools available, perhaps a kiln, and a system set up for firing work and for glazing, probably with specialist knowledge at hand for advice. This naturally makes life much easier for someone planning clay work with a class for the first time. More likely, you will find a situation where clay is used only sporadically throughout the year, for a whole variety of reasons. This can be because

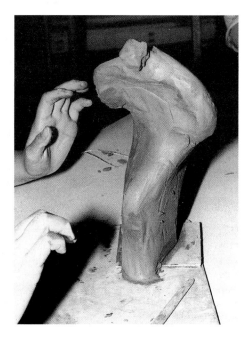

of: the demands on time of other important aspects of the curriculum; the difficulty in gathering the necessary resources together, and of course a lack of familiarity on the teacher's part with clay. How curriculum time is managed and prioritised is a matter for the individual teacher, but developing and organising resources is a simple problem to solve. Most of the clay work illustrated in this book was organised from three large plastic stacking storage boxes. These could be moved from room to room quite easily, and contain all the tools and bits and pieces needed to work with a whole class.

Unless you are in a very large school it is unlikely that you will have a specialist area to work in. You may have a wet area adjacent to the classroom which would be suitable, or perhaps some tables reserved for art and craft activities. These would allow for small group activity with say 6-8 children at a time but if the classroom has plastic topped tables you can deal with the lesson as a whole class activity.

Clay storage

Clay from your supplier will arrive in a polythene bag. If this has not been punctured in transit, the clay will remain in a workable state almost indefinitely. It is worth

Left
Modelling the 'Figure in the wind'.

Right
Danielle, aged 11, 'Figure in the wind', Fired black slip coating

checking carefully for damage, and wrapping the bag again if holes are found. If you are intending to keep clay readily available in the classroom then damp storage is essential. It is suggested that you use a plastic container large enough to hold at least two or three 25 kg bags with a layer of heavy plastic in the bottom. This will help to keep the clay above any water which settles there. Leave the clay in the suppliers bags, and reseal carefully any that you use. Cover the clay with a heavy layer of wet fabric, lightly squeezed out, and then cover that with more polythene and the lid to retain the moist atmosphere. Every three weeks or so check the fabric and re-soak if necessary. If you follow this method you will find that your clay is always ready to use.

Working Methods

Modelling

The finest tools that we have as human beings are our hands, and it is in the development of fine motor skills that claywork has a particular and special place in the educational experience of young children. By developing sensitivity and control in using their fingers and hands in conjunction with this soft and malleable substance children begin to acquire an instinctive physical understanding of the properties of the material and an increasing confidence in their own ability to form.

At an early stage the teacher needs to encourage children to explore fully the range of manipulative possibilities at their disposal. This will include shaping clay just with the fingers, squeezing and rolling it into small pieces with delicacy and precision, working a larger piece with one hand, and holding a lump with one hand whilst working it with the other. Such movements will range from quite fine actions to much more vigorous poking, slapping and squeezing responses. The full range should be experienced to provide the children with a broad base of practical knowledge from which to draw in the future.

The work made in this manner often retains a directness and spontaneity of handling which is fresh and delightful, and the children quickly learn the importance of fine motor skills and care in handling the clay.

Working with a block of clay

Presenting children with a large lump of clay is an immediate challenge to them both physically and imaginatively. Some will approach it initially in a very physical way – pinching, hollowing, squeezing and flattening it. Gradually the shape may suggest an idea for a form, an animal or a head perhaps, and they will then begin more controlled and structured modelling. Others may have a clear idea from the outset what they intend to make. Either approach is perfectly valid, and may require little initial stimulus from the teacher other than encouragement to explore their ideas freely. They will discover by pulling out the clay that legs, ears, noses, snouts and all manner of other forms can be suggested, and by poking in with fingers or modelling tools eyes and mouths can

Left
Ashley, aged 8, 'Frankenstein', unfired clay

Right
Jack, aged 11, 'Two standing figures', based on the work of Armitage

30

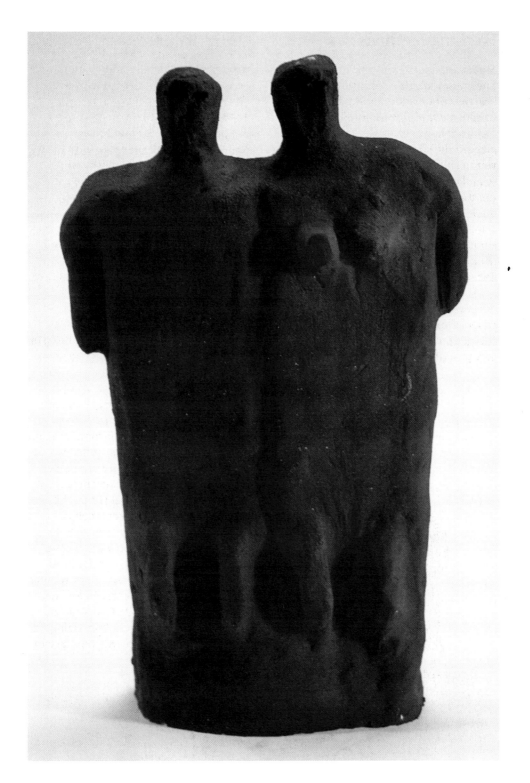

be formed. Working with a lump of clay encourages a particularly sculptural approach to modelling because children have to consider the whole form at once, and begin to think about it as a fully three-dimensional object. They are obliged to explore the mass of a form and the space around it when they pull out legs and arms etc. and these experiences are important elements in children's perceptual development. It is likely however that when children are faced with this experience for the first time, they will concentrate on the front of whatever they are making. This is natural because they are used to working in their drawing and painting on a flat sheet of paper. It may require some encouragement by the teacher for them to begin to realise that the back is important as well.

Carving into a block of clay

This is a particularly sculptural method of working, involving cutting clay away from a mass to reveal a form inside, and from a conceptual viewpoint it requires children to think about a subject in a subtractive way. This is not easy for many children, although the actual process is quick and direct. Using wire loop modelling tools the clay can be cut away very simply, and if mistakes are made it can be just as easily replaced. If you suggest to the children that their subject is hiding inside, this will often capture their imagination and add an element of excitement to the exercise. The clay for this work needs to be grogged and open in texture because the results are likely to be quite thick in section and will crack in drying if the clay is too fine.

Twin pegs and base armature.

Using armatures

Traditionally sculptors have used a support called an armature inside the clay when they have modelled larger forms. This can be made from wood, metal or aluminium rod, wire mesh, or a combination of these. It has to be made strong enough to take the weight not only of the clay, but also of the plaster if a mould is subsequently to be taken. If the work is to be fired, obviously any armature must be removed. I have found that occasionally there is a place for the use of simple armatures when working with children. Small supports can be made using dowel rods on a plywood base for supporting small figures and larger armatures can be made using heavier timber attached with metal angle brackets to a base. The advantage of such supports are that the children can model freely without having the problem of the soft clay work collapsing. There is further information on armatures for plaster in the next chapter.

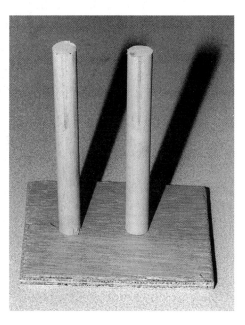

Working on a larger scale

Armatures allow for larger work to be produced by the children, but scale itself can produce some problems. If the children are working with a large solid block of clay, perhaps by combining carving in as well as adding onto the mass, the finished work will be too thick and heavy to fire. The heads were made in this way using a coarse grogged clay, and the children completed the modelling without problems. They then had to be hollowed out, and to enable this to be done, the work was left partly covered overnight to harden up slightly. A wire was then used to cut them in half vertically to remove

Right
The Robot head armature.

Below
Hollowing out the head.

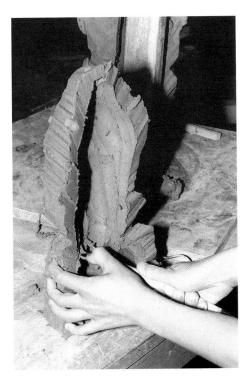

the form from the wooden armature, and the two halves rested gently on a thick cloth to avoid distortion. The two halves were then hollowed out carefully with wire loop tools to a thickness of around 3/4 in. or 2 cm and then carefully joined together again working the joint both inside and out for strength.

Working in Relief

Modelling in relief to make panels or tiles for the decoration of buildings is an art form and process which goes back into history. There are three broad types of sculptural relief modelling, Low relief, where the form stays quite close to a flat surface, High relief, which allows for

greater articulation of the form, and bas relief, where parts of the form detach themselves from the background. In practice there are often combinations of these types in a single piece.

Making tiles or flat clay slabs is quite simple provided that certain basic methods are observed.

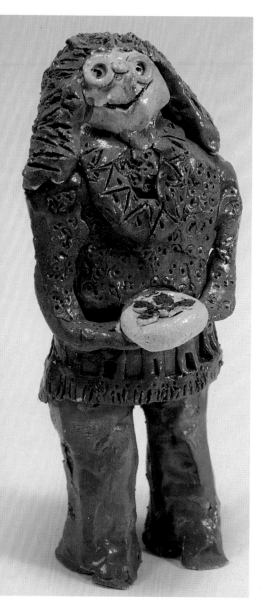

1. Give thought to the clay you are using. Ideally the clay should contain some sand or grog which will allow a thicker section to be worked (between 8-12 mm) and allow the children to exploit the natural texture of the clay. This can be controlled by the thickness of the guides used.

2. If you only have a smooth dense clay available it is advisable to make the tile thinner, say 5-8 mm, and not to have a finished surface larger than 6in. (150 mm), preferably smaller. This will help to prevent cracking and warping during drying.

3. Make sure that there is a layer of polythene, or preferably paper, underneath the tile so that when the children press the surface it does not stick.

4. Give thought to the ways in which you want the children to work the surface. If they are building up texture by adding on coils and shapes, provided they don't make the tile too thick, the results should be satisfactory. If they are drawing or cutting into the surface with a stick or a modelling tool, or impressing a deep design, however, there can be problems. This is because when the clay is moist the tile appears to be in one piece, but as it dries and needs to be handled it breaks into small pieces, which is a real disappointment. This can be a particular difficulty with very thin tiles, and I suggest that drawing in thin clay is avoided if the work is to be kept.

Left
Emily, aged 8, 'Lady with biscuits', modelled on a peg armature, coloured with slips, earthenware fired

Right
Gina aged 8 'Singer', glazed earthenware

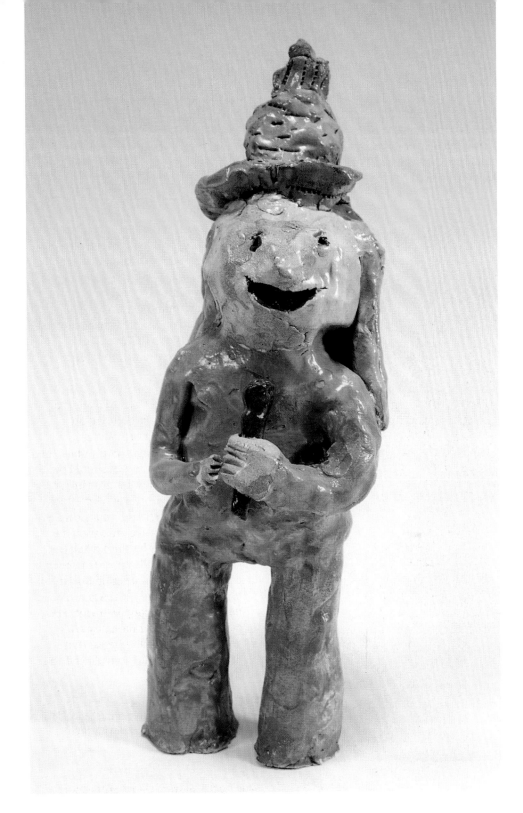

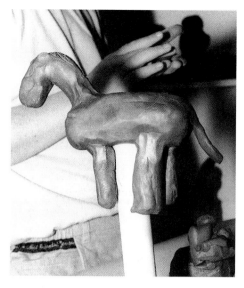

Above
Modelling a horse on a peg.

Above
Lyndsey, aged 9. Terracotta form based on drawings of eyes and mouths.

Below
Modelling in 3-D from pastel drawings of body parts.

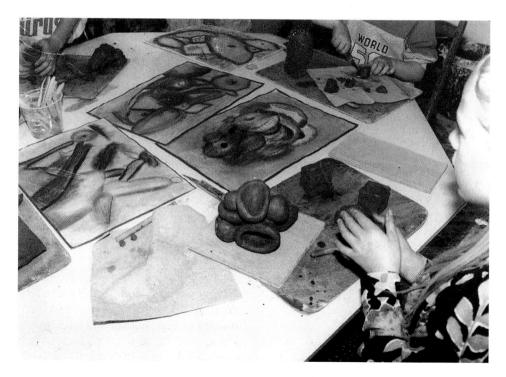

5. The real problem with tiles comes in the drying stage. It is here that a more open grogged clay has an advantage. If the tiles are left out to dry on a board, the top surface dries more quickly, and they curl up at the edges. Sometimes this can lead to quite large cracks developing. The secret is to slow the drying down by placing the tiles onto corrugated card or something similar, covering them with polythene, and turning them over once or twice to allow both sides to dry evenly.

Casting from clay

This involves covering the clay with liquid plaster of Paris, usually pouring the plaster inside a frame to contain it, and then when it is set, the clay is removed leaving a negative impression. It is a nice simple way of getting children to consider positive and negative surfaces. I have dealt with the practicalities of this process in more detail in the next chapter.

Another method which is perhaps less risky than that of using liquid plaster, is to take a cast using plaster bandage from a clay modelled form. With this method the form is modelled in clay, and then covered with a layer of thin polythene sheet or cling film. It is important that there are no major undercuts to prevent the plaster layer from being lifted off easily. A least three layers of plaster bandage are then applied to the clay model, paying particular attention to the edges so that they are strong enough to stand the pulling when the plaster is removed. The masks were made in this way.

Surface decoration on clay

Prior to firing there are two basic methods of enriching the surface of the clay. The first is by physically altering the texture of the surface by incising or adding on clay shapes. The second is by painting onto the leatherhard surface a layer of one or more coloured clay slips. These slips can be purchased from an educational supplier, or made yourself using ball clay to which colouring oxides have been added. The slips should have a consistency similar to single cream, and soft fluffy brushes should be used to apply them to avoid damage to the modelled surface. The application of a glaze will bring out the strength of the colour, which tends to be somewhat muted after the first biscuit firing.

Firing and glazing

Why fire?
For children to fully understand the change which occurs from clay to ceramic it is important, if possible, that they experience it at first hand. It is a most exciting process, and one which even professional potters and sculptors find continually fascinating. To commit your most precious work to a fire, and then to have to wait to see the results builds an anticipation and tension which is quite unique to the craft. For children to see this happen is to experience the concept of change in an immediate way, and relates directly to the science curriculum, particularly energy transfers, and reversible and irreversible change. In this case, irreversible. There are also some wonderful historical links with primitive kilns, in that all the Iron and Bronze Age, Roman and Medieval pottery and sculpture which we see in museums was fired in simple pit or

clamp kilns using wood as a fuel. In parts of Africa today large handbuilt pots are still fired in bonfire kilns using brushwood as a fuel.

If an electric kiln is not available in your particular school, there are simple ways of firing using sawdust and bonfire kilns which are very effective. It is outside the remit of this book to cover the firing and glazing process in detail, and there are many publications available which provide this information for the enthusiastic teacher. There are examples of finished fired work throughout this chapter.

Other modelling materials

There are other modelling materials aside from clay which can be used with children for small scale sculptural work.

Playdough and salt dough are very similar, except that playdough is cooked before use, and saltdough is cooked after modelling.

Playdough
Ingredients
200 g plain flour
1 tbs oil
100 g salt
300ml water
2 tsp cream of tartar
a few drops of food colouring

Place the flour, salt, oil and water into a saucepan, and then add the food colouring to the water. Slowly add the liquid to the mixture, stirring thoroughly to get an even texture. Place the pan on a low heat and keep stirring. The liquid mixture will suddenly thicken, and you should keep stirring until it becomes very stiff. Scrape out the dough onto a smooth surface and allow to cool, then knead thoroughly until it becomes

pliable and smooth. Store in an airtight container to stop it drying out, and it will keep indefinitely. After modelling it can be allowed to harden in air.

Saltdough
Ingredients
300g plain flour
1 tbs oil
300 g salt
200 ml water (approximately)

Mix all the ingredients together in a large bowl until pliable, adding more liquid if necessary. Knead well until smooth and elastic on a floured board. It should be stored in a plastic bag in the refrigerator, and it improves with keeping becoming less grainy and smoother. It can be coloured with food colouring as with playdough, or it can be painted after cooking with poster paint. It can be cooked on a greased baking tray at gas mark 4 (350°F, 180°C) for around 20 minutes to make it hard. Timing depends upon size. Larger items should be cooked on a lower heat for longer to prevent cracking.

Plasticine is also useful for small scale work, although it is much more expensive than clay, and not as malleable.

PROJECT 1

Looking at the sculptures of Kenneth Armitage

Children aged 11
Starting points Photographs of the sculptures. Themselves as models.
Materials Grogged stoneware clay. Black and Grey slip.

The children were introduced to the work of Kenneth Armitage, and particularly asked to think about the way the

human figure and groups of figures were represented. They discussed how the human form might be simplified and reduced and still remain recognisable as a single figure or group of people. What were the most important features of the subject and what feelings do you get when you look at these sculptures?

Having explored this starting point, the children were given paper, soft pencils and charcoal, and encouraged to produce an impression of their ideas. They were not trying to design a final piece, or to copy the work they had seen,

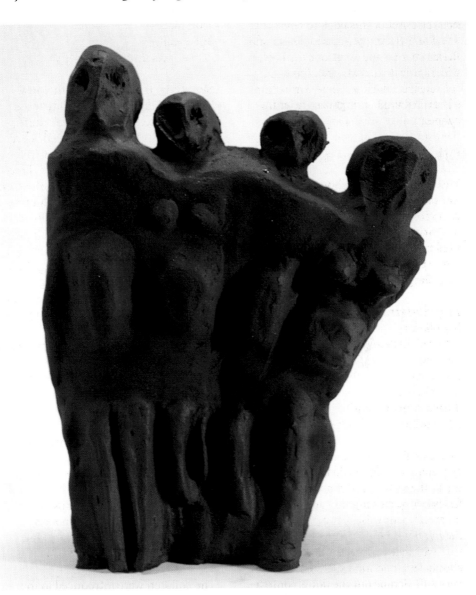

Craig aged 11, 'Four figures', Stoneware, black slip

but to suggest some very broad and personal ideas as to how their final work might look, and to provide a clearer basis for subsequent work in clay.

Once they had decided this, they were given some grogged stoneware clay and began to model their ideas working from a solid block. Because they were working on a relatively small scale it was not necessary to use an armature to support the forms. Although most of the group decided to work on groups of figures, Danielle developed a very strong idea about a figure walking into the wind (page 29). It is a wonderful example of the results of giving children a strong stimulus and then allowing them to develop their ideas on their own.

When the work was finished, it was carefully sliced in half with a wire, and the interior hollowed out. This is essential if the work is to be fired because if the clay is too thick there is a danger of the piece disintegrating in the kiln because of the water content. The work was then joined together, painted with black or grey slip and fired.

In a separate project a similar process was used to make the large heads but in this case, because the children were working to life size, a wooden armature was used to support the clay whilst they modelled the forms. They were then cut, hollowed and joined as has just been described (page 33).

PROJECT 2

Working from natural forms

Children aged 10 -11
Starting points A collection of exotic tropical seed pods and shells.
Materials Grogged stoneware clay.

The children were given a collection of

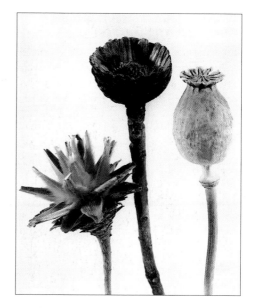

shell and seed pod forms to explore. As before, they discussed these, and made drawings to understand the forms. In this case they were not asked particularly to develop the starting points in an imaginative way, but to look closely at their chosen subject, and to show their understanding of their form and its surface in clay. The work was made hollow using the coiling method, and surface details modelled on afterwards.

We were concerned here with developing and sharpening perceptual awareness and translating this understanding into clay.

The work was subsequently fired with a wash of iron oxide to bring out the surface texture (pages 18, 20 and 41).

PROJECT 3

Imaginary people

Children aged 7-8
Starting points Discussion about people in different situations. Looking at sculptures of standing figures.

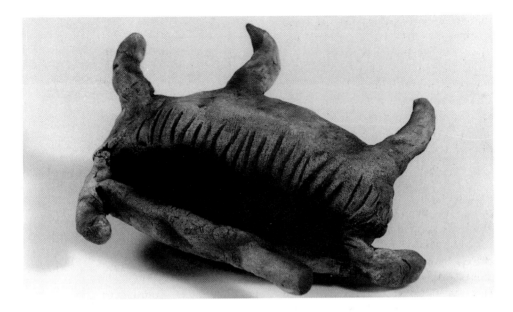

Left
Seed pods and dried flowers.

Materials Peg and base stands, grogged stoneware clay.

The children looked at sculptures by a variety of artists, and were asked to think about making a standing figure of their own engaged in some sort of activity.

Once they had a clear idea for their subject, they wrapped a layer of paper around the pegs, and modelled the clay onto them to form the legs. The bodies were built on top of these with the pegs providing support for the clay. Once the modelling was complete the figures were slid off the pegs and laid down to dry before firing and glazing. Where the clay was thick a wooden dowel was pushed up to allow the moisture to escape easily from the interior of the form during firing (pages 24, 30, 32, 34 and 35).

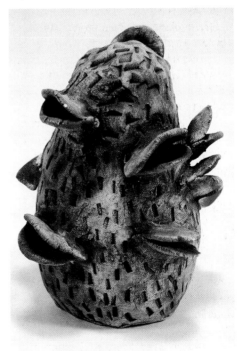

Chapter Three
Plaster of Paris

The material

Plaster in its various forms has been used as a sculptural medium for centuries, indeed it is known that a type of plaster was in use by the Sumerian civilisation around 2500 BC. This was made by grinding gypsum or chalk, mixing it with ground stone dust and glue size, and allowing it to set hard.

The name 'plaster of Paris' comes from the Montmartre area of that city, where gypsum was quarried to make the type of plaster which we use today. Now, of course it is quarried throughout the world. Gypsum rock is solid and crystalline in nature, but quite soft, and the plaster is made by heating this to around 350°F (150°C) to dehydrate and decrystallise the rock. This is then crushed and finely ground to make the plaster powder.

When water is added to this powder, it recrystallises back to its original hard and solid state, which makes it extremely adaptable for three-dimensional work.

There is a wide variety of types of commercially available plasters. These range from very fine white hard Dental plaster, to the familiar coarse material which is used to cover walls. In addition, and of particular value in the primary school, is plaster-impregnated bandage, the working of which is discussed later.

What we have then with plaster is a material which is easy to work, which can be used for taking casts from other objects and surfaces, and which may also be used in conjunction with a variety of supports for making large structures with the children. It is physically quite strong, although still soft enough to carve, and it is easily coloured either during use or afterwards. The principal disadvantage of plasterwork in school is the potential for creating a mess, and the fact that it is not particularly weatherproof if the work is to stand out-of-doors. These problems, however, can largely be overcome with good classroom organisation and suitable treatment of the finished surfaces, and the possibilities for creating really exciting artwork is, I believe, well worth the trouble.

The potential of plaster for work with children

Provided that the practical planning and organisational side of the work has been carefully considered, plaster offers many possibilities in working with young children. Since it normally sets in between 15-30 minutes, the working time is short, and this leads to quick results. Additionally, it can be used both for fine small-scale work and, in conjunction with suitable structural supports, larger objects may be quickly and easily constructed. These may either have a bulky mass, or be more open and spatial in character. A wide variety of

surface qualities and textures are also possible, depending upon how the plaster is used, and once it has set the surface is quite strong.

In broad formal terms there are three obvious ways in which this material can be used with children:

1. To make relief casts from other surfaces or materials.
2. To build up a form which is supported underneath by an armature made from wire or wire mesh, wood, paper and card, metal rods, or a combination of these materials.
3. To carve the form out of a cast block of plaster.

These processes are covered in greater detail later in this chapter.

Essence, aged 6, 'Ladybird', Plaster bandage, paper and wire

Classroom organisation and equipment

Organisation
It is essential that practical steps are taken to minimise mess when using plaster. If you are lucky enough to have a spare room in the school which can be used for this type of construction work, then this will help considerably. If not, there are some simple measures which can be taken in your planning to facilitate the activities in your usual classroom.

Firstly, try to arrange the work as near to the sink as possible. This will help to contain the plaster, and prevent children moving around the whole room with plaster on their hands. Ensure that there is plastic sheeting over all working surfaces, and that the bag of plaster powder is near to the sink, and also

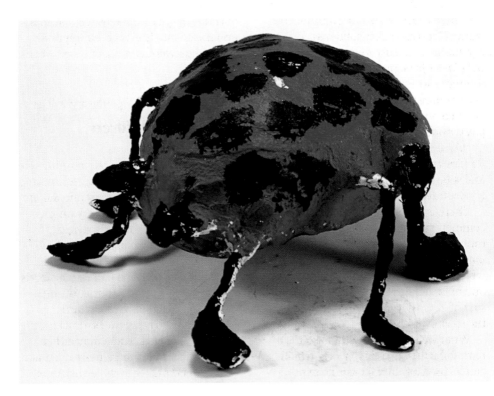

standing on plastic sheeting. Make sure that the sink has a waste plug in place to prevent spare plaster from blocking the waste pipe. When the work is finished, the water can be released slowly, and the plaster sediment scooped into a bag for disposal. A separate bucket of water for the children to wash their hands in will help to avoid problems with a blocked sink. You will also need to have a waste bin near your work area to scrape spare plaster into. This similarly should also be lined with a plastic bag to assist disposal.

Floor areas near to the workspace should be covered with newspaper to protect the floor from possible spillages and dusty footprints.

Plaster bandage work can be contained on a table surface, and because you are not mixing plaster powder, there is less likelihood of making a mess with this material. It is a good practical alternative for smaller scale working.

If all these precautions are taken and the children act sensibly, there should not be any problems.

Equipment

The equipment for this activity is quite minimal. You will obviously need a sink and cold water. A variety of containers for mixing different quantities of plaster are also essential. If you can obtain plastic buckets or washing bowls which have some flexibility, this will help in removing spare set plaster afterwards. For mixing small quantities, a plastic football cut in half is an ideal and cheap container. Plaster bandage only requires a shallow flat-bottomed dish of water to wet the bandage prior to use.

Mixing and working plaster

The method of mixing plaster is quite simple, but there are certain things which are important if a correct mix is to be obtained. Firstly, the water should be cold. If warm water is used, the plaster will set much more quickly, thereby limiting the working time. The container should also be clean. If pieces of set plaster get into the mix, they are difficult to remove and make a lumpy mixture.

The volume ratio of plaster to water is roughly equal, so you will need to visually assess how much you will need. Before you begin, make sure that everything is ready to receive the mixture.

Method

Put the cold water into the mixing container. Using your hand or a plastic scoop, sprinkle the plaster powder evenly across the surface of the water. Continue to do this until you can see that the water is not absorbing any more powder, and that there is a small mound of plaster on the top. This shows that you have a saturated solution of plaster, and that the correct balance of water to plaster has been achieved. You can then put your hand into the mix and give it a thorough stir, making sure that the mixture is lump free and smooth. It is absolutely essential that you do not stir the mix whilst you are adding plaster powder, because it becomes impossible to gauge the strength of the mix if this is done. If you do not use enough plaster, the resulting mix will be spongy and weak.

The more the mixture is stirred, the quicker it will set, so if you are modelling with it, it is best to leave it alone once it has been mixed. Depending upon the age of the plaster, your working time will be around 10-25 minutes. The older the plaster is, the more likely it is to set quickly. Fresh plaster which has been kept in a dry atmosphere will give you the longest working time. Once the

plaster has begun to recrystallise and become stiffer, you will need to work quickly to use it up. It is a useful tip when first working with it, to use smaller mixes until you find out how much actual working time your particular plaster will give you. It is also useful to scrape out your mixing bowl before the plaster sets completely, as removing set plaster is time-consuming and tedious. You should also make sure that you wash the plaster off your hands and arms before it sets, particularly if you

have hairy arms. It can be a bit painful if you forget!

Using plaster bandage

As has already been mentioned, plaster bandage is much easier to use than powdered plaster. You will, however, need to make a support onto which the bandage can be draped and formed because it is very floppy when it is wet (see Constructing armatures and supports). The method of use is simple. An appropriate length of material is cut with a pair of scissors, and pulled steadily

Robert, aged 11, Cast plaster relief from clay.

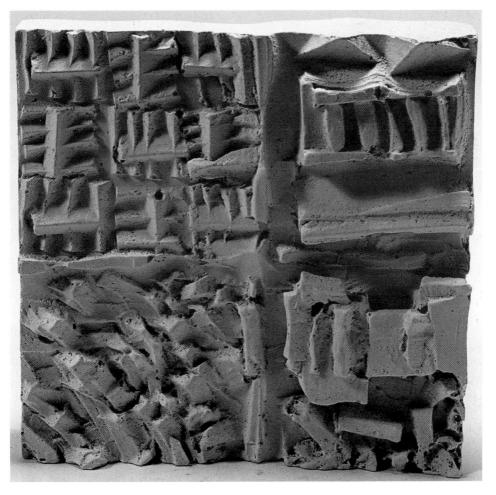

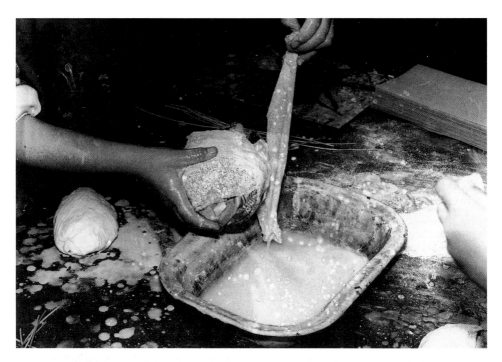

Wrapping a paper former with plaster bandage.

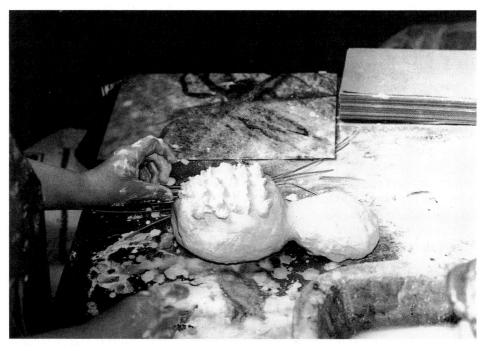

Adding texture to the body of a spider.

through a shallow tray of water. It is then wrapped over the former, and the surface smoothed with the fingers. When it has set, usually in about 10 minutes, another layer or two are then applied to the first one. Three layers are normally sufficient to provide a firm surface, but this will depend to some extent upon what has been used as a support. If paper is used, it should be crushed firmly and wrapped with tape. It is particularly important that whatever support is used, it should be shaped in such a way that it is as near to the final form as possible. It is a waste of material to try to build up a thicker form with thin bandaged layers. Once the main form is covered, smaller details and surface texture can be developed with small pieces of material. If thin legs are required, for example, with an insect, wire can be pushed into the main form, and then secured and wrapped with more bandage.

Casting plaster

There will be times when plaster is used for pouring into a mould, or onto a relief surface. This will require a framework to contain the liquid plaster, and these frames are usually made from clay if they are quite shallow, or from plywood boards if the mould is deep. Whatever method is used, care should be taken to ensure that the mould is well supported to take the weight and pressure of the liquid, and that all the joints are well sealed with clay to prevent the liquid from leaking. Once the plaster has set, the boards can be removed easily with a gentle tap. If a more rounded shape is required, a piece of thick card can be used as a container instead of wood or clay, although you will still need to take care to seal the joints, and the card will

stick more firmly to the plaster afterwards.

Relief casts

The traditional sculptural use for plaster was as part of a casting or mouldmaking process. It allowed a negative piece mould to be taken from a modelled clay original, which could then be used to cast the form into a more permanent material such as bronze, or in more recent years, concrete or fibreglass. This lengthy process is of course not appropriate for the primary school, but simple casts can be taken from clay originals, and are an exciting way of teaching children about positive and negative surfaces. They may well be aware of this concept through the simple printmaking processes which they have covered elsewhere in their art sessions, but the texture and tactile quality of a relief casting is a very different experience from the flat surface of a print.

Constructing armatures and supports

Traditionally sculptors have used a wide variety of armatures and supports in making their work. The essential requirement of any armature is that it is strong enough to take the weight of whatever material is to be used on top of it. This might be clay or plaster, or both, if the piece is to be modelled and then a plaster mould is taken from the original. For our purposes in working with young children I have tried to keep these suggestions simple and easy to use. The type of support to be used with plaster will vary according to the scale of the piece envisaged, and whether it is to be a bulky form or more linear. You will probably need more tools to make armatures,

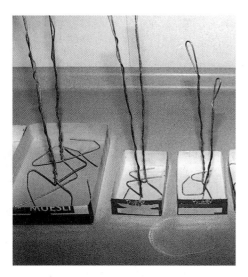

Preparing to cast plaster bases for wire armatures.

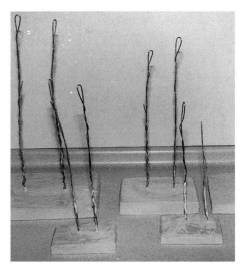

The casts complete, ready for the children to shape their figures

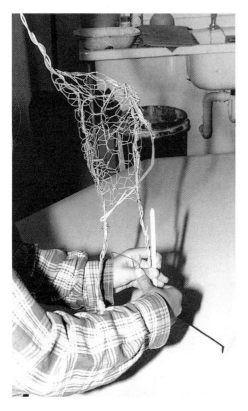

Constructing a wire and wire mesh armature for a figure.

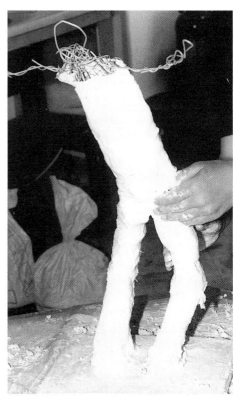

Covering the armature with plaster bandage.

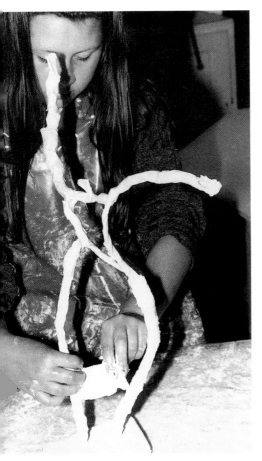

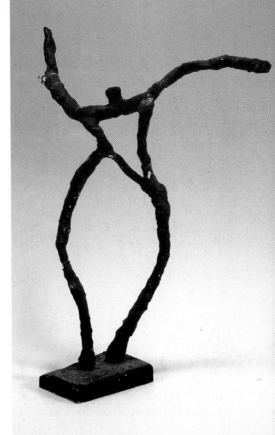

Above
Covering the wire with plaster bandage.

Right
Sarah, aged 11, Abstract dancing figure.

including wire cutters and pliers, and a hammer and nails. Depending upon the scale on which you intend to work, it is likely that you will need to be actively involved with the children in the initial construction of thearmature, and it is important that there is an open dialogue at this stage in deciding what the form will be like. It is also a good opportunity to set the children practical problem solving questions, and for the group to try to work these out for themselves under your direction.

Whatever type of armature you are building, it is very important to ensure that it is made as close to your final form as possible. Once plaster has been added it is extremely difficult to alter the proportions and form of the piece. Similarly, if the form is bulky, the surface of the armature needs to relate to the intended final surface of the piece in order to avoid building up very thick and heavy layers of plaster with the attendant problems of support.

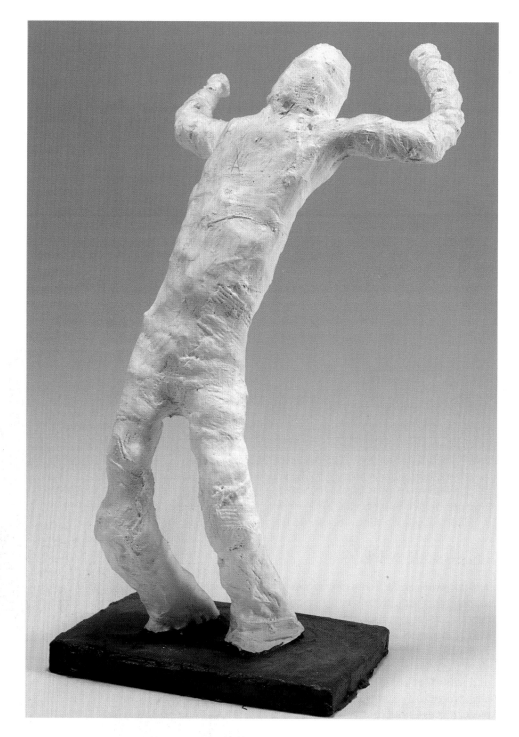

Oliver aged 11, 'Leaning figure'

Small-scale work

For small-scale work, (up to say about 12 in.), making figures using plaster bandage, wire is an ideal armature. It may be bent into a variety of shapes, and will provide a strong enough support for the weight of the wet plaster bandage. It can be made more bulky by the addition of crunched up paper held in place with tape. Make sure that the children work with shortish lengths of wire, around 30 in. maximum, because if they are given long pieces they tend to forget that there are two ends, and there can be some risks to their neighbours! A good tip is to fold over the end which is not being used when they are first beginning to shape the wire (see Chapter 7).

You will need a good pair of pliers or wire cutters to prepare the wire for the children before the lesson. More bulky forms on this scale, such as heads, fat bodies etc. can be supported by scrap cardboard wrapped in firmly compressed newspaper, held together by tape. The nice element in working on this scale is that the work can be picked up and turned around. The children have to think about their work in a fully three-dimensional way, and because it is small and light weight, this is quite easy to do.

Large-scale work

The larger the scale you work on, the more important it is to have a strong support. There is nothing worse than to have a nice piece of work collapsing under the weight of the plaster. You should err on the side of caution here, and allow for the enthusiasm of your class in applying heavy plaster to the piece. It is essential that you prepare

carefully when undertaking such work. Consider what will be an appropriate structure for the piece. Will it require some metal rods or strong timber to hold the weight, and how will it be joined to a base to ensure that it remains vertical. The base, usually a piece of timber board, should be large enough to keep the piece stable when the plaster is being applied. Suggestions are given later as to how this may be achieved.

Armatures for larger hollow forms

The basic armature can be constructed from steel rod or wood. Wood has the advantage over metal, in that cross pieces can be easily nailed on to enlarge

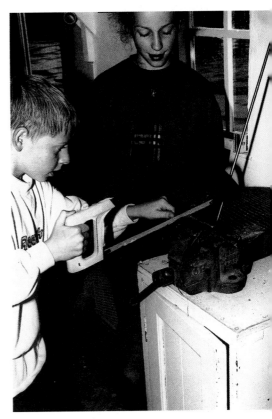

Cutting steel rod to length.

51

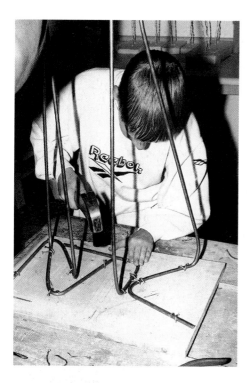

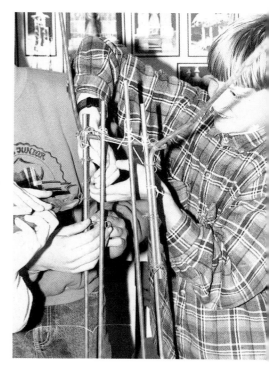

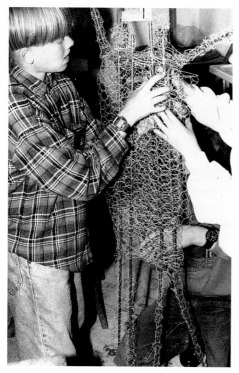

Above, left
Nailing the bent rod to a baseboard

Above, right
Twist wiring the rod together using pliers.

Left
Covering the frame with wire mesh.

the form. Over this can be placed chicken wire or heavyweight cardboard strips to make the bulk of the form, stapled, nailed or tied onto the underlying structure. Make sure that everything is fixed securely.

Building forms

Once the armature is completed, plaster can be applied. It is better to start at the base of the form and work upwards. This gives strength to the structure, and prevents it becoming top heavy. For

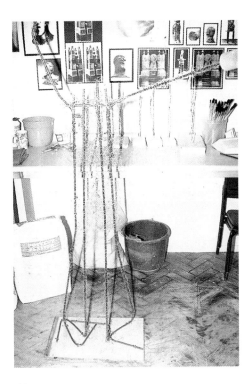

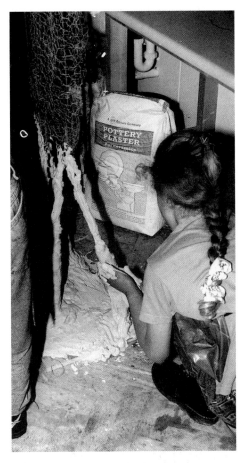

Above
The completed armature for 'Watchers.'

Right
Starting to cover the armature with plaster soaked hessian.

larger surfaces, an initial layer or two of plaster-soaked open weave fabric (see below) is an ideal method of covering the form quickly. Once this has set, more modelling can be developed using smaller quantities of plaster.

Using plaster with fabrics

This is a very quick and effective method of covering larger surfaces. The fabric used must be very open, hessian or burlap is ideal. The method is quite simple. Firstly, cut the fabric pieces to a manageable size for the work in hand. It is important to have plenty of pieces

available so that you are not rushed when the plaster starts to set. Mix a quantity of plaster in the usual way, and then place it alongside the work. The fabric is then simply pushed into the plaster and thoroughly coated, then lifted up onto the armature and smoothed out. Let the first layer set before you try to apply the second, or you may find that the weight begins to deform the cardboard or chicken wire underneath. It is important that the plaster is near the form, because excited children with dripping fabric can quickly create chaos. Spare plaster in the bucket can be scooped up with the hand before it sets and added to the form.

Casting from the figure

Very interesting work can be produced using the children themselves as models from which casts are taken. It is essential that they wear old clothes for this!

The method is quite simple. The subject is placed in a position which is comfortable and well supported, because he/she will have to keep quite still for around 30 minutes. An area larger than that from which the cast is to be taken is covered with a layer of moderately heavy polythene sheeting. This is then covered with two or three layers of plaster soaked fabric and allowed to set. It is important that only the top half of the form is covered. If you wrap it around you will have an encased child! Once it has set it can be lifted off quite easily, and perhaps in conjunction with other casts can be used to create a shell-like assemblage of forms.

Covering a modelled clay head with layers of plaster bandage.

Below
Painting the plaster cast

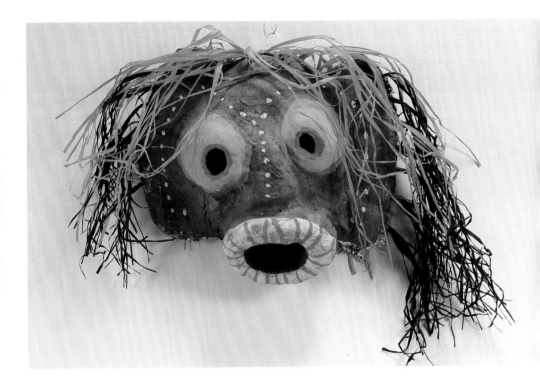

Making moulds from clay originals

This, as has already been mentioned, is a traditional sculptural process. The form is modelled in clay, supported by an armature, and then a plaster cast is taken from it, often in many sections. This inevitably is a lengthy and quite skilled process, and once the mould has been made, it will need to be filled, with concrete or bronze for example, to produce a more permanent form. This procedure is of course inappropriate for our age range, but an understanding of it has a place when we are looking at the work of professional sculptors. Most bronze pieces will have been originally made in clay or wax before undergoing this casting process, and sometimes the casting joints can be seen on the final piece. There are simple ways however, in which children can take casts from their modelled claywork.

Luke, aged 9, 'Mask'

Below
Carved wood Tibetan mask (collection of the author)

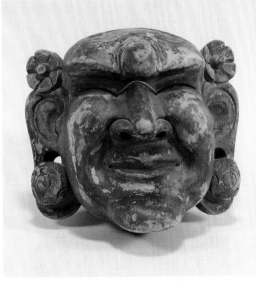

Relief panels

Negative casts are quite straightforward to take from low relief clay panels, and the positive/negative change which this produces is always intriguing. The method is simple.

Place the panel or panels onto a flat smooth board, and build a wall around them using clay, wood strips, or thick card. The wall needs to be at least 1 in. higher than the highest part of the modelling to allow for the thickness of the plaster. If using wood or card, make sure that the wall is secured on the outside with more clay, so that the plaster cannot run out. Mix up the plaster, and pour it into the mould whilst it is still runny to pick up all the detail. If the casts are to be displayed on a wall, you can add a loop of wire to the back to hang them from. When the plaster sets the clay can then be removed and the panel washed in water with a bristle brush to clean it thoroughly, revealing your negative surface (see page 45).

Carving plaster

All carving processes tend to be slow, and involve careful use of tools. For young children, carving into soft malleable clay which offers little physical resistance is ideal for introducing them to the concept of revealing a form hidden inside a mass. Plaster, which is harder, offers much greater resistance, and only the older children will manage to handle mallets and chisels safely. The blocks of plaster will need to be fairly small, up to 9 in. in any direction maximum, because the larger the block, the longer they will take to finish, and as

Left
'Beowulf' Relief panel using plaster bandage on cardboard

previously mentioned, it can be a slow process. The blocks will need some support on the table, such as a strip of wood to prevent them from sliding around too much when they are being carved. The children will also need plenty of room, so this has to be a small group activity. The most important issue with carving has to be proper instruction in the use of tools. All the time they have a mallet in one hand and a chisel in the other there is no risk. But if they put the mallet down, and try to hold the work with one hand and carve with the other, there is a real danger of the chisel slipping and causing injury. Carving in plaster is not likely to be a common activity, but under proper control and supervision, many older children enjoy the physical and creative engagement of working into a mass.

Finishing for interior display

How the final surface is left is a matter of choice. The crisp whiteness of plaster is in itself quite attractive, but it can easily be painted. Normal poster or powder paints, mixed with water and a little PVA glue as a binder will seal the surface perfectly adequately. Some thought needs to be given to the selection of colour here. A complicated form is often best left in one overall colour, rather than being further confused by a variety. Beware of high gloss treatments. The reflections which can be caused may lose attractive and subtle surfaces.

Finishing for exterior display

Plaster will not withstand prolonged exposure to the elements. It is porous, and is easily broken up by frosts if not treated. The best treatment for outside display is to seal the surface with two coats of exterior varnish after any colouring has been applied. It is essential

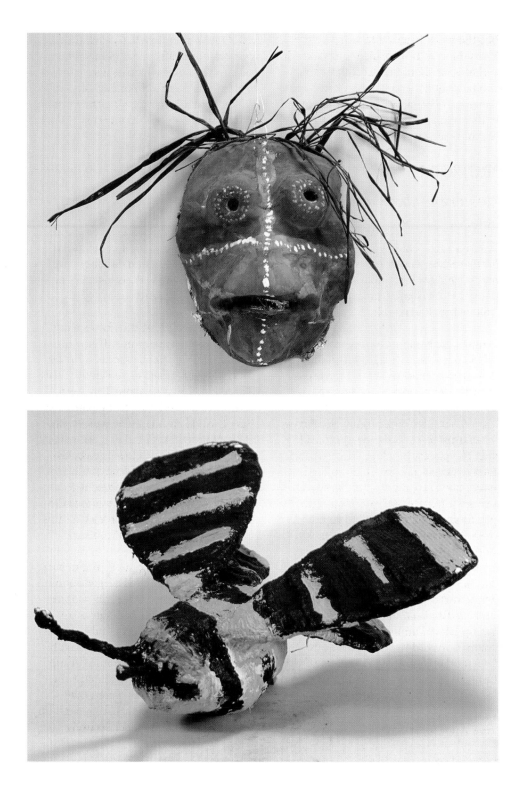

that the work is absolutely dry before this is done or the varnish will flake off, so the work should be left indoors for a couple of months to dry out. The strength of the piece will be determined by the quality of the armature, and the thickness of the plaster.

PROJECT 1

Plaster bandage and wire insects

Children aged 5-6
Starting points Looking at a variety of insects, spiders, caterpillars etc.
Materials Newspaper, tape, thin wire, shallow tray and plaster bandage.

To make the bodies, newspaper was rolled up into a fairly tight form and held in place with masking tape. It is important that the paper is quite firm to provide a strong support for the bandage. Where two paper forms were to be joined, this was also done with masking tape. The plaster bandage was cut into smaller pieces, and the children were shown how to apply the bandage in overlapping layers. Wire was cut into lengths with pliers by the teacher, and when the plaster had firmed up (after about 30 minutes) the teacher made holes in the bodies with a pointed rod and the wire was inserted. The wire was then joined to the bodies with several small pieces of bandage and allowed to firm up. More bandage was then wrapped around the legs to thicken them, and textured details were added to the bodies using very small pieces of

Left
Above Adam, aged 9, 'Mask'

Below Juliene, aged 6, 'Bee'

bandage. When they had dried, they were painted with poster paint. Wings were made using a loop of wire filled with several layers of bandage and left flat on the table to set before they were joined on (pages 43, 46 and 58).

PROJECT 2

Dancers

Children aged 9-11
Starting points Sculptures of the figure by various artists, and photographs of themselves moving and dancing.
Materials Plaster of Paris, plaster bandage, tape, galvanised wire.

To save time, a number of bases were made prior to the sessions. These were produced using small cardboard boxes from the junk modelling collection, cut down to make trays about 1 in. deep. Wire was cut and bent at the bottom so that it would stand in the trays. Plaster of Paris was then mixed and poured into the trays and allowed to set (page 48). This quickly gave a stable armature for the children to work on. The children were asked to think about figures moving in space, and to concentrate on this element of movement rather than details.

They then bent the wire, and in some cases added more by twisting it on to develop their forms. Once this was complete, strips of plaster bandage were added to thicken the form and keep the wire rigid. The work was painted with poster paint when dry. Another group decided that they wanted to make the figures more bulky, and before they added the plaster bandage, they built up the forms with newspaper securely wrapped with tape.

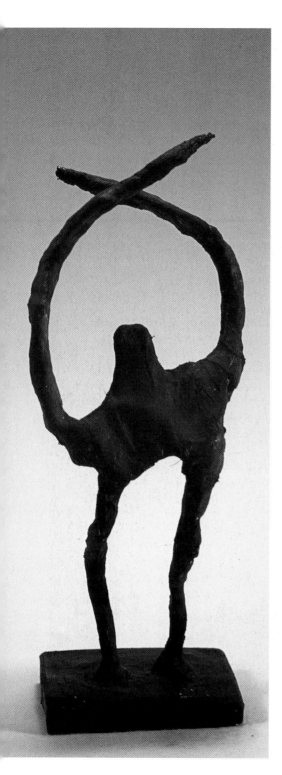

PROJECT 3

Watchers

Children aged 11
Starting points This group decided that
they wanted to work large and make
some figures doing something. They had
seen the Giant being made, and after
discussion decided that their figures
should be watching and pointing.
Materials Round steel rod, wire mesh,
galvanised wire, wooden base, hessian
scrim.

Having decided the pose, the group
made the armature by cutting, bending
and nailing the rod to the base. Arms
were added to the structure and held in
place using thinner wire tightened with
pliers. Shorter lengths of rod were added
in the body area to provide extra
stability and strength. Wire mesh was
cut to shape with pliers and wrapped
around the steel frame to build out the
form, and held in place with wire. Once
the armature was complete, small quan-
tities of plaster were mixed in a bowl
and using strips of plaster-soaked
hessian, the piece was gradually covered
starting from the bottom. Once the form
was completed, a thin slurry of plaster
was used to create a textured surface,
and to complete details on the heads.
The whole project took just a day, and
the children learnt a tremendous
amount in the process, and were
immensely proud of their achievement.

Left
Sarah, aged 11, 'Dancer'

Right
Jason, Rachel, Adam, aged 11, 'Watchers',
48 in. high

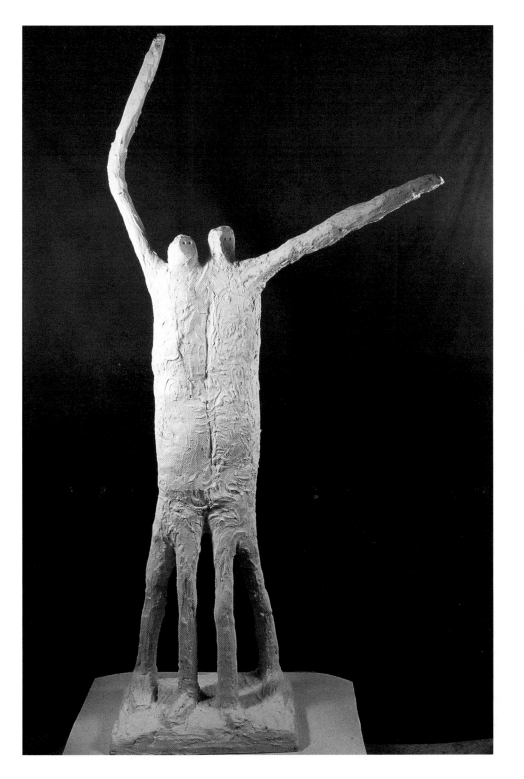

Chapter Four
Card and Junk Construction

Potential for three-dimensional work

The use of found and waste materials for the creation of artwork has a long tradition in our schools, both in the development of ideas in two dimensions through the collage process, and in the construction of three-dimensional works.

It is a medium which can be used across the whole age range with equal ease, and allows for work on a variety of scales. The principal practical advantages of card and junk construction over

some of the other materials in this book are its cheapness, because most of the materials being used are waste materials which would normally be thrown away. Another important factor is that these materials are relatively easy to work, even with very young children, and as they are generally clean to use, this makes classroom organisation much simpler.

The construction processes which these materials require make particular demands on the children's creative thinking. They have to relate the subject or ideas which they have to the various shapes and forms of the material, and select those items which they feel are most suitable for their subject. These elements may have to be changed and modified in shape and proportion to fit the subject, and then joined together. This is a process of trial and error, and requires a constant decision making and problem solving interaction with both the material and the idea.

There is an important design and planning issue here as part of this creative activity. The children are engaged not only in an interaction with the material, but also in thinking through the construction process as a sequence of stages. They will need to plan either individually or as groups how to join and build their work in the

Armen, Jason, Claire, Chris, aged 10-11, 'The Iron Man'

most effective way, and they may need advice or questions from the teacher to get them to think about these problems. For example, with simple animals they might have to consider turning the body upside down to join on the legs, before they work on the head.

The process is very open-ended, and I have found that when presented with such work there is often much valuable interaction within the groups. They have to negotiate between each other in selecting the elements which they require, and there are always some individuals who will come up with some original ideas for the forms, and ingenious ways of modifying the forms and joining them together. The others learn from this and then bring their own solutions to the work, resulting in a lively interchange of ideas and practice which tends to generate real excitement and engagement.

Found materials

For this work to be successful there is a need to build up a good quantity of resource material from which the children can select.

Asking parents to save materials for the work can be very rewarding, and in my experience can be overwhelming, so a suitable storage area is essential. Cardboard boxes can be used to sort and arrange the materials as they are brought into school.

The type of materials which are commonly available are: cardboard boxes and packaging in a wide variety of sizes; cardboard tubes, again in a variety of sizes and diameters; egg boxes; plastic margarine tubs; bottles and yoghurt containers, and scrap card sheet from manufacturers, if you have the contacts.

Sean, aged 6, 'Blue sausage dog'

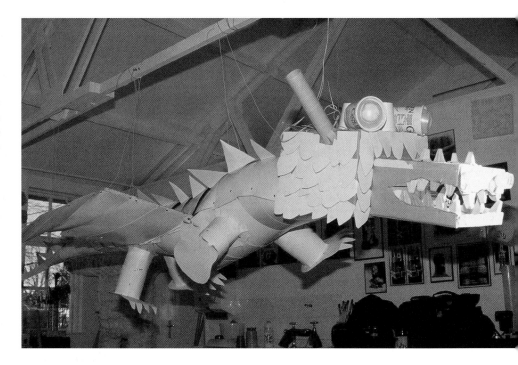

In fact anything which can be easily cut, shaped and joined, and which has an interesting form. Often parents will offer surplus materials from their factories for use in school, and this can stimulate ideas for work across a number of classes.

Practical problems and skills

Before you begin working with these various materials it is useful to consider how you are going to finish the work. If you intend to paint them with water-based paints it may be necessary to turn card boxes inside out, because the external finish and printing may resist the paint and make it difficult to cover the design. There is a similar problem with painting any plastic items which you use. There are suggestions later as to how you can overcome this, but some initial thought and planning can save problems later.

Cutting

Most of these materials can be cut easily with normal scissors, which the children can do for themselves. However, heavier card is more difficult to cut, and they might require some support from the teacher using a sharp craft knife to cut out for them. Individual circumstances and common sense will dictate the solution.

Joining

There are two basic methods which can be employed with these materials either separately or in combination. The choice will be determined by the age and skill of the children, and whether you are using just cardboard, or a combination of materials with different adhesive properties.

Mechanical fixings

Split pins or staples are a very effective method for joining thin card. Split pins, for example, were used in conjunction with a hole punch to construct the body of the large dragon, segment by segment, working down the body towards the tail. The children quickly learned to work together and systematically to achieve this. Staples on smaller scale work are also effective, although there can be more problems here with the physical pressure required to press the punch.

Adhesives

There is a large range of glue adhesives available for this work, most of which are used in schools, but there are some important practical points that should be considered when using them. The most important in my experience is their strength and the speed with which they set. PVA glue is a commonly available glue, and it is strong once it has set, but if you are using it on a larger structural piece you might find that you will need to use paper clips, tape or staples to hold the surfaces together whilst the glue dries. This can slow down the creative flow of ideas and cause some frustration with the less patient children. Working on flatter surfaces where there is less structural pressure it is very effective. For smaller constructions, glue sticks are very effective and give an almost instant bond. The most valuable joining method that I have found in making larger work is that using a heated glue gun. There are some important health and safety factors with these, in that the heat can cause burns. I organised the work so that only the teacher used the gun, and there were no problems. It is best to not

Left
'Dragon', Group work by children aged 8-9

Below
Painting the dragon.

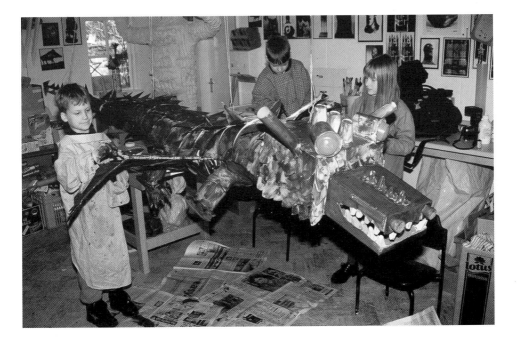

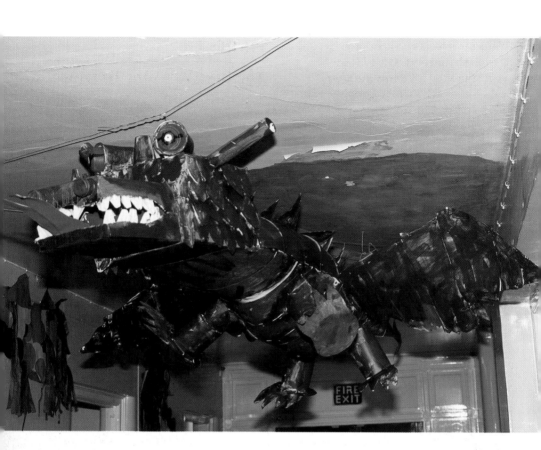

Dragon hanging in the corridor.

have more than one gun in the class-room so that the children don't get tempted to use them. The beauty of a glue gun is the speed and strength with which quite large and difficult materials can be joined, particularly plastics to each other and to cardboard. Plastics are especially difficult to join with many glues.

Other adhesives include various adhesive tapes such as packing, masking and sellotape. These are effective and quick, but can look unsightly and clumsy. There can also be problems if the work is to be painted, because the water will soften the adhesion and the work can fall apart, which is rather dis-concerting for the children!

Finishing and painting

It is likely that you will need to paint the work on completion, and provided you have used just cardboard, standard powder paint or poster paint is quite effective. You need to make sure that the children don't use too much water or there is a risk of the card becoming satu-rated and it may start to collapse. Fairly thick paint should be mixed to try to avoid this, and it will give a better cover-ing. The real problems of painting arise where mixed materials have been used. To finish these and to provide a good opaque covering you can either use powder paint mixed with PVA glue plus water, or use prepared acrylic paints. The latter tend to be more expensive, and for large-scale pieces, powder and

PVA is the obvious choice. Larger brushes should also be used to cut down on the time needed to cover the work.

For some work spraying may be the only solution. The Iron Man and Woman were both sprayed with a silver aerosol paint to finish them, but this was done outside the classroom for safety reasons because of the fumes given off.

Spraying does make covering complicated forms much easier, particularly where the inside can be seen and is difficult to reach with a brush.

Children aged 10-11, Shell construction. card and wood wire.

PROJECT 1

The Iron Man and The Iron Woman

Two groups of 4 children aged 9-11.
Starting points The two books by Ted Hughes.
Materials A collection of cardboard and plastic junk material, wood strips, glue gun, and silver spray paint.
The children formed themselves into two groups, and made drawings based on the subjects in the book. They had to think carefully about the materials which were available to use, and spent some time moving back and forwards

Shell construction.

between their drawings and the large collection of junk material.

They found that their initial ideas had to be adapted to what was available, and gradually decided amongst themselves what they might use as a basic structure for the bodies, legs and arms. Once the body had been selected, they were faced with the problem of joining cardboard tubes securely onto it. After some discussion they solved the problem by making a series of short cuts around the end of

each tube, and folding the card out to make tabs. These were then joined onto the body by the teacher using a heated glue gun. Other glues could have been used but had the disadvantage of being less immediate. They found that this method of cutting the ends of the tubes also allowed the tubes to be joined easily at an angle, at the elbows for example. Other elements were then selected to make the hands, fingers, feet, neck and head. Strips of plastic were added for hair, and wooden offcuts used to build up texture on the bodies.

Throughout the process many different shapes were tried for effect, and there was some excellent discussion and group decision-making in both groups. This didn't deal with just practical issues, but also with much critical visual analysis.

Once the construction was completed the work was taken outside and sprayed with a layer of quick drying silver paint to unify the form. Because there was a mixture of materials, plastic, cardboard and wood, an aerosol paint was used. Poster paint would have given problems of uneven covering, particularly on the plastics.

PROJECT 2

Large Dragon

This was made by a whole class of 7-9 year olds, working in teams of 6 or so for periods of around an hour.

Starting point The class were working on a topic of the Vikings, and had been involved in work exploring Norse mythology. They decided that they would like to make a large dragon to hang in the corridor outside their classroom (see pages 64-6).

Materials Cardboard boxes, wood, wire, sheet cardboard offcuts from a factory, split pins, glue gun, staples and poster paint.

The head was made by gluing two large cardboard boxes together, and then cutting the front one to form the mouth. Two lengths of wood were glued securely to the inside bottom of the rear box to provide a strong join between the head and the body. Two 9 in. long lengths of strong galvanised wire were joined to this wood to give a flexible framework for the body and tail. The whole structure was then suspended on wire at a height which made it easy for the children to work on. This enabled the children to work all around the dragon at the same time. The head was developed by adding eyes (yoghurt pots), ears and cardboard scales to cover the boxes. The body was constructed from strips of card, working from the head to the tail. Each strip on both the top and bottom was joined at the same time by punching holes with a stationery punch, then pushing a split pin through and bending the ends around the wire from the inside to keep it in place. The children, working together, quickly grasped this simple system, and worked very well as teams. The method produced a wonderful segmented structure, very appropriate for the subject. The wings were made from a frame of stiff wire, and filled in with strips of card, folded over and stapled. These were joined to the body by means of a wooden frame securely attached by wire. The children needed help with this, and there was a great deal of discussion and experiment to work out the best way of achieving this effectively.

Once the body was completed, a double row of scales was glued to the back all the way down. The legs were made

from tubes of card sheet attached by the tab mthod described in the previous project.

The work was finally painted with poster paint and enthusiastically hung outside the classroom. It took under two days to complete, working with small groups for short periods of time.

Ben aged 6, 'Horse'

PROJECT 3
Shell constructions

Children aged 10-11.

Starting point The visual focus for this work began by looking at shell forms, and spirals in nature, and developed onto ideas about the spaces between, around and inside forms. I found that

these older children were ready and able to deal in their own way with the more abstract concepts of space and form, and move on from a more literal interpretation of the subject to explore the ideas in a more open-ended way.

Materials Wire, wood, cardboard strips, staples. hand drills. acrylic paint.

The children looked closely at the subject, and began to discuss the structure and symmetry underlying the forms. They were aware that there was a central axis, and that the spiral was a basic mathematical form. Ideas were then considered as to how they might begin to use this to make structures which had some of these qualities. Various materials were suggested, and in the end they decided to use wood, wire and card. They decided to use a length of wood as the central axis and build the forms around this, and by drilling the wood in different directions were able to thread the wire through to create a more open structure. They were asked to think about the strength of form of the shells, and try to make sure that the wire retained some of this quality with good strong lines in space. They then began to give the structures more substance by using strips of card stapled around the wire. They found that they could only think about the work in a fully three-dimensional way by suspending them so that they could turn them easily, and look at what was happening from different directions. Gradually the structures developed, and they found that the strips of card began to suggest planes, some of which intersected and passed though each other, whilst others remained separate. All the time they had to make judgements about how the whole piece was looking from different directions. They found this a more and more intriguing experience and became quite engrossed in the problems. When the work was finished they decided that they needed to be coloured, and they were sprayed with acrylic paint. Hand painting would have been difficult because of the final complexity of the work.

Chapter Five
Wood

Wood is a material which has been used for sculptural work for centuries, and by every society. It is probably the most common material surrounding you in the school, and whilst the children will be able to identify it, they will only come to understand its various properties by working with it themselves.

They need to become aware of the wide variety of types of wood which we have around us, that it can be hard or soft, and that unlike other materials which they will know, such as clay, wood has a grain. This is an important factor, directly affecting the way we work it.

Wood can be cut, carved and joined relatively easily by adults, but as it is the most resistant material we are likely to use with our children, it has to be recognised that there are some limits as to what we may expect the children to achieve with it in an average classroom situation. The factors which affect this are the age and physical abilities of a particular child or class, the tools and equipment which are required to work safely, available space, and the particular type of wood available.

Types of wood

There are two broad categories of wood available, hardwood and softwood. This is available with a sawn or planed finish. For school use I would recommend a smooth planed finish because there is less chance of the children getting splinters. Softwood generally comes as a type of pine, which has an open grain and often quite a few knots. It cuts easily, but tends to split if you try to join it with nails, particularly with the thinner sections. The principal advantage of pine over hardwoods is that it is a little cheaper.

Hardwoods tend to have a much closer and more even grain, and within this category there are timbers which children can work quite readily. In particular, Jelutong is ideal for primary work, and most educational suppliers stock bundles of this wood in a variety of sections – round, square, sheet and rectangular for use in Design and Technology projects. The large structure in Project 1 at the end of this chapter was made from these supplies. The form in which wood is available determines to a large extent the potential sculptural subjects. Architectural starting points and light open structures are some obvious possibilities.

Whichever type of wood you use, I would recommend that you stick to fairly light sections to make cutting manageable, and in lengths of no more than a metre (3 feet). If you use anything longer than this, you might find that working space becomes a problem.

Right
Children, aged 10, 'Deer', Found materials

Structure and working properties

All wood has a grain, and children will discover, or need to be shown, that they need to allow for this when they are working. The fast-growing softwoods have an open grain, whilst the much slower growing hardwoods have a closer and more even structure. Cutting wood is much easier across the grain than down the length.

Using found materials

There is considerable creative potential in exploring natural materials which you may find in your local environment near to the school or on field trips. These might include fallen branches, twigs, grasses, willow and bamboo. Anything in fact which could be assembled to produce a three-dimensional object.

There are a number of internationally recognised contemporary sculptors who provide precedents for this, including Richard Long and Andy Goldsworthy. By coincidence, Andy Goldsworthy actually worked for a short time some years ago in the Harrogate school where the work for this book has been produced. Although their work is far more conceptual, these materials can be readily used for subjects which are more appropriate to young children, for example, animals, birds etc.

Tools

The basic tools required to work with wood are generally available within the Design and Technology area. It is useful, though not essential to have a few benches with vices attached for holding wood in different positions, and to provide a work surface for drilling and gluing. The essential tools are small handsaws for cutting to length, coping saws for cutting holes and joints, hand drills, and some rasps or surforms with glasspaper for shaping and finishing.

A number of bench hooks are also

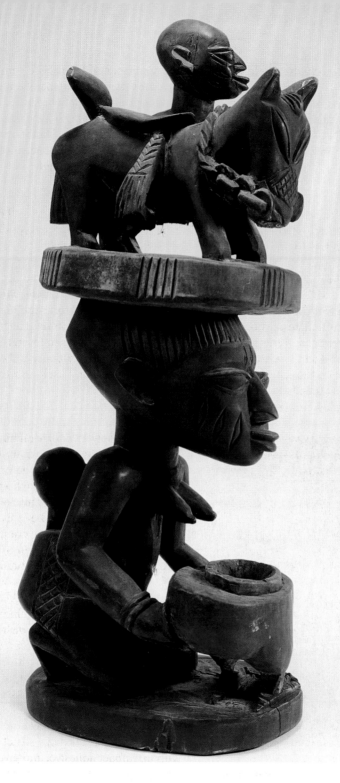

'Mother and baby, man and donkey', Yoruba carving from Nigeria (collection of the author)

essential to help the children hold the wood in a safe and steady way when they are learning to saw, as are a few small hammers for driving in pins and small nails.

Techniques

Cutting

It is important that the work is held firmly using either a bench hook or a vice when using a saw to prevent the children from cutting their fingers. They need to be taught to stand properly with good balance, and to keep the saw in line with the forearm to prevent the blade breaking or jamming. The pressure should be quite gentle, and the speed of sawing should be steady, but not fast, to allow the blade to do the cutting. When using a coping saw the blade should be tight and not twisted, and because the

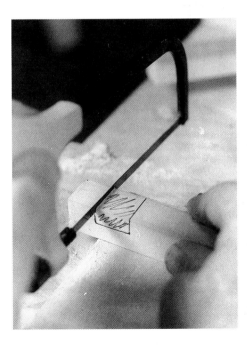

Cutting wood using a handsaw and bench hook

blade is thinner all the above points regarding stance and control are even more important. If a hole is to be cut out of sheet material, it will need to be predrilled to thread the blade through, and the children will probably need some help with this initially.

Drilling

As with cutting, the work must be firmly gripped, and the hand drill kept vertical to avoid breaking the drill bit. It is useful to rest the work on some scrap material to avoid drilling holes through into the bench. Often the children will work in pairs doing this, with one holding the work and the other drilling. They will need to be shown how to reverse the drill to withdraw it, because if they try to pull it out they are likely to break the bit.

Joints

We are not likely to involve children of this age in learning how to make the large variety of common wood joints, but for some projects the simple cross-halving joint has a value. This was used on the Puppet in Project 3 of this chapter. It was made by marking out the saw lines on each piece of wood, making two cuts halfway through with a hand saw, and then removing the waste wood with a coping saw with the work held firmly in a vice. The joint was then glued.

Butt joints are very weak with most glues, but a heated glue gun can be very effective provided it is used with care and with Health and Safety in mind. The large architectural piece was assembled completely with butt joints and a heated glue gun. Small card triangles are commonly used for technology structures with an impact adhesive, and give a stronger joint, although they can look visually intrusive for sculptural work.

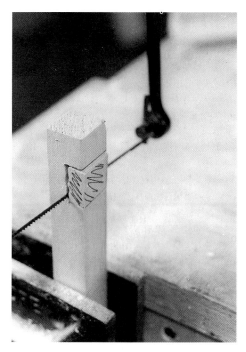

Joint marked out on wood.

Right
Removing waste wood with a coping saw.

Gluing

There are a variety of glues available for wood, but many suffer from the disadvantage of taking time to set, and I have found that with this age range, speed of construction is important if the children's concentration and enthusiasm is to be maintained. PVA adhesive is good and will set in about half an hour, but the work must be held firmly during this time and not moved. There are a number of impact adhesives for flat sheets but you have to be careful here because some give off fumes, and cannot be used in school. The fastest is a hot glue gun, but as I have mentioned this will have to be used by the teacher for safety reasons. It does, however, give a strong and instant join.

Classroom organisation

There are no specific difficulties in using wood in the classroom, other than those relating to space and safe working. It is a clean material and produces little mess, but is likely in practice to be limited to group activity simply on the ground of available equipment, tools and suitable bench space. The organisational problems associated with materials such as clay and plaster are much less acute than when working with wood.

Health and safety

As a clean non-toxic material, wood presents no problems, but the safe use of tools will need to be taught, and reinforced. The glue gun should only be used by a teacher to avoid the risk of burns, and in my experience this is the only major problem working with this material.

PROJECT 1

Architectural structure

Children aged 9 -10.
Starting Points Looking at the structure
of local buildings.
Materials Assorted lengths of wood,
saws and glue gun.

This project started from a topic on
materials, and looked at the way we con-
struct buildings, the different ways we
use materials like wood, bricks and steel
to make houses, high-rise buildings and
factories.

The structural principle of the post
and lintel was discussed, and the
children thought about how they might
use the idea of verticals and horizontals
to make a large sculpture. They decided
that it should not be symmetrical, as this
would make it more interesting. Four
lengths of wood were selected and cross
pieces were cut and glued to make two
sides. Other pieces were then cut and
glued to make a basic tower form which
would stand vertically. The work then
gradually developed out from this both
vertically and sideways, with the
children deciding collectively where to
place the cut pieces. The finished piece
stood around 4 feet high, and using the
glue gun it took less than a morning to
make. It was subsequently used as a
subject for some interesting pencil and
charcoal drawings.

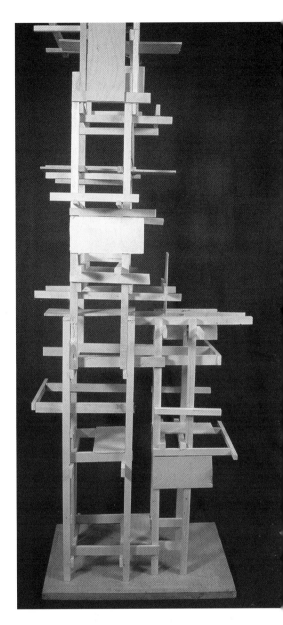

Architectural structure. Children aged 10

PROJECT 2

Working with materials found in the environment

Children aged 10.
Starting point In this case the ideas
developed from the shapes and forms of
the materials, and resulted in a deer
made from bamboo, and a bird made
from twigs and grass (see page 73).
Materials Twigs, grass, cut bamboo,
and string.

Wrapping grasses around a twig frame to make the body of a bird.

This project took place in a local wood, and was initiated by the local town art gallery which invited two sculptors to work with children and adults using natural found materials. The ideas for subjects developed out of the materials which were available, which included tree branches, twigs, grasses and long bundles of green bamboo brought in from a local park. There were a few tools available, and some string and wire. The children decided that a bird would be a good starting point, and found some lengths of twig which were tied together to provide a basic structure. This was then wrapped with long lengths of dried grass to build up theform of the body, neck and head. Wings and a tail were added using the leafy tops of the bamboo, and the bird was suspended from a tree. The children found this a fascinating problem, and then decided to work

Bird hanging in a tree.

on a larger scale using a deer as the subject.

Bundles of bamboo were tied together to make the legs, and small holes were dug into the ground to hold them vertical. The bundles were then bent in half and tied together to make the body, which gave a very strong structure. Other lengths of bamboo were inserted and tied in to build up the form, and further lengths were added to make a neck and head. These were also thickened up to give more bulk.

Some twiggy branches were selected to make the antlers and tied in. The whole structure took less than an hour to make, despite it being a very wet day, and the finished work looked quite at home in the small clearing.

PROJECT 3

A Puppet

Children aged 10-11.
Starting Point A design exercise to make a marionette with moving legs and arms.
Materials Plaster bandage, wood strips, screw eyes, paint, fabric, fishing line.

The children began by making drawings to work out how the figure might articulate and discussing various possible solutions. They also had to work out the proportions of the figure, and how the head might be made. They settled for using plaster bandage over a paper ball for this, as they had previous experience of this, and decided that it must be quite light in weight. The wood was cut to length for the various components of the body, and they then realised that they would need to make two cross joints on the body. They were shown how to mark out and cut these joints

'Puppet head', Plaster bandage with wire loops top and bottom.

using a handsaw and a coping saw, and the wood was glued together. Screw eyes were inserted into the ends of the arm and leg components, and these were joined together by opening out one of the eyes with pliers, threading it through, and then closing it again. This made a secure but flexible joint. Hands and feet were cut out of flat sheet using a coping saw, and joined on to the body. The children then had to work out how to string the figure to support it and to get it to move properly. This was done by hanging the puppet from a cross frame and stringing each part separately. A pattern was then made to work out the size of the clothing, and fabric was then cut and stitched to complete the work.

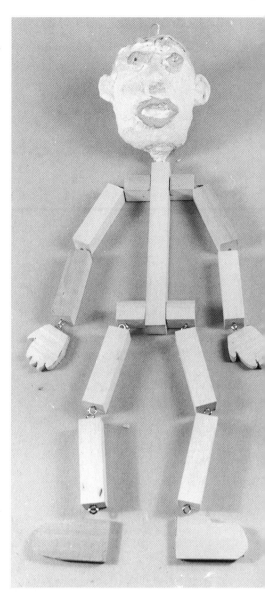

Cutting out puppet hands using a coping saw.

Right
Completed puppet ready for stringing and clothes.

The head was painted using poster paint with PVA for a durable finish. The children learnt a great deal about working together and solving problems from this project, and also much about new materials and processes.

Chapter Six
Wire

Wire in various forms has been found to be an extremely useful and versatile material in the production of much of the work in this book. It may be used on its own as an expressive medium, or in conjunction with other materials. It can be used for work of different sizes, is relatively easy to manipulate (particularly with fine wire) and it also has structural strength if heavier gauge material is used.

In visual terms wire can be considered as a line or drawing in space, with many of the visual qualities of a drawing on paper. This line can be tense, soft, complicated or simple depending on how it is bent and changed, and I have found that children readily respond to its expressive potential. The important visual and expressive quality of wire lies in the ways open spatial structures can be produced and explored by the children quickly and easily, and in the ways ideas and forms can be altered and changed. The skills required to manipulate it are fairly straightforward, although some simple tools are needed for heavier section wire and mesh.

Available types of wire

Round Wire
This is available in rolls or bundles, and in varying thicknesses. The lighter gauges are probably the most useful as

Nichola, aged 10, 'Wire figure'

the children can bend this easily. This wire may come with a galvanised finish or just as a normal iron colour. Both are equally satisfactory. The only real problem with rolls of wire is the tendency for children to get the roll into a tangle and start cutting off lengths at random. You need to teach them to work from a free end to avoid this.

Wire Mesh
This is more expensive than coiled wire, and has a more specialist application. It comes in rolls with various mesh sizes, and I have found that a mesh size of around 3/4 in. (20 mm) is probably the most useful. It is used to build larger

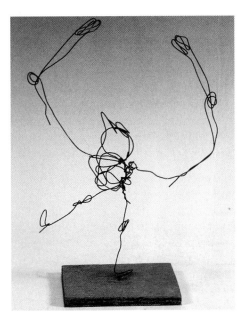

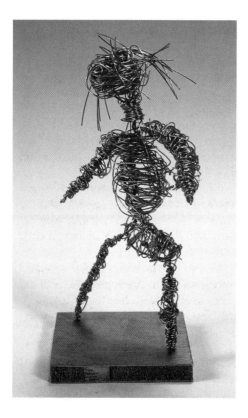

Sam, aged 11, 'Spikey warrior'

forms over an underlying armature, which can then be covered with plaster bandage or hessian soaked in plaster. This gives a strong and light form, and an example of this can be seen in Project 2 at the end of the chapter on plaster (see page 59).

Tools

The only tools needed to work wire are small pairs of pliers and a pair of strong sheers, for cutting the heavier gauges. I found that most children over the age of 8 were perfectly capable of using these tools to produce their work, although the strength required to cut heavier wire occasionally required assistance from the teacher. They did need to be shown that pliers have both a cutting and a gripping action, but once they had learnt the manipulative skills they worked with the pliers quite easily.

Working methods

Wire is a medium which can be manipulated easily by even young children, but the thickness is important. The heavier gauges require more strength and should only be used with older groups. The thinner wire can be bent and formed with little pressure, wrapped around to build up a form, and is particularly useful for twist-tying materials together. This is done by taking a short length of wire (around 4 in.), folding it in half for extra strength, wrapping it around the joint and twisting the ends tight with pliers.

If you only have thin wire, and wish to have more structural strength, this is achieved by taking a long piece, folding it in half and twisting it tightly. A quick way of doing this is to put the folded end in a vice, or loop it around a door handle, and put the other ends tightly into a hand drill bit. The wire can be very quickly twisted together in this way.

Safety
Wire tends to be quite springy, and long lengths can be dangerous. If children are working in close proximity it is *essential* that they work with shorter pieces, and that *the free ends are bent over* to conceal the sharp point. The teacher needs to be constantly alert to this danger, and the risks need to be pointed out to the children. I found that with children under the age of 8 it was safer to give them shorter lengths (around 12 in.) from the start to avoid this danger. The older children were more aware and sensible, and once that

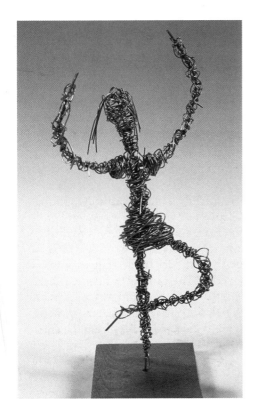

Hayley, aged 10, 'Dancing lady'

the dangers were pointed out, they bent over the ends almost automatically.

PROJECT 1

Wire dancing figures

Children aged 10-11.
Starting point Photographs of sculptures and themselves dancing.
Materials Wire (two thicknesses), pliers and small wooden bases.

The children looked at photographs of the work of a number of sculptors, and also at photographs of themselves dancing. They decided for themselves the pose for their figures, and whether they would be standing on one leg or two.

The wooden bases were then drilled with a fine drill to enable the wire to be inserted to hold the figures vertical whilst they were being worked on. The slightly heavier wire was cut into lengths of about 12 in. (30 cm) and used to make the general form of the figure. The thinner wire was then wrapped around the form to build it out, and in some cases it was cut into shorter lengths to produce details such as hair. The figures were then adjusted to balance on the bases and in some cases bent, to improve the flow of movement in the form.

In a similar project, another group were involved in developing the drawing exercise of taking a line for a walk. In this case the line was wire, and they explored taking a line for a walk in space. The figure was again used as a starting point, and they were given a longer length of wire. The only restriction was that they were not allowed to

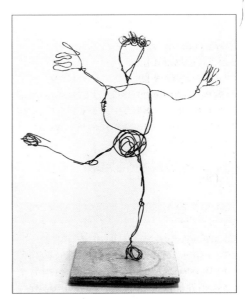

Jemma, aged 10, 'Taking a line for a walk figure'

83

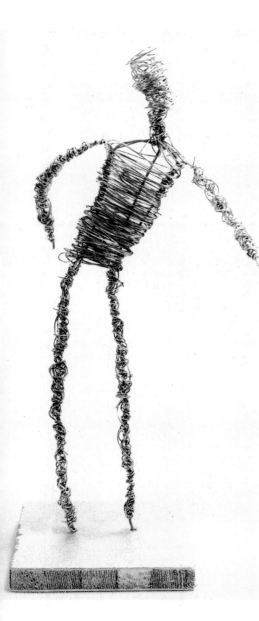

Holly, aged 11, Dancing figure

join on another piece. They found this quite intriguing, as the practical and design problems were different from anything they had encountered before. The end products had a special vitality and delicacy which were quite distinctive for such a simple problem.

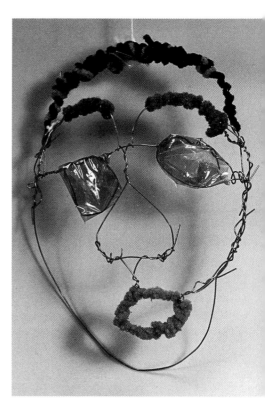

Richard, aged 9, Wire face

PROJECT 2

Faces

Children 8-9.
Starting point Themselves.
Materials Soft iron wire in 12 in. lengths, pliers, coloured cellophane, transparent tape and coloured pipe cleaners.

The children were shown the wire and the problem of making a face was discussed. They then began by making careful pencil drawings of each other using just lines, and were asked to think as they were doing so how they might adapt and develop their drawings using the wire. They then made the faces,

joining the lengths of wire by twisting them around, and cutting shorter lengths where necessary. They decided when they were almost finished that they needed something else to make the faces more exciting, and coloured pipe cleaners were wrapped around the wire to give it more visual weight. Coloured cellophane was also added using small pieces of tape to join it to the wire. This kept the delicacy of the original structure whilst enriching at the same time.

PROJECT 3

Children aged 10-11.
Starting point An exploration of the visual element of space in 2 and 3 dimensions.
Materials Paper, wire and tissue paper.

The children were given a long strip of paper and asked to fold or bend it into as interesting a spatial form as they could. They then made drawings of their construction from various angles to try to explain and understand their subject in two dimensions. Using these drawings and their original paper form they were then asked to develop their ideas using wire to make another interesting structure. This was developed further by wrapping the wire form with coloured tissue paper glued together with watered down PVA glue.

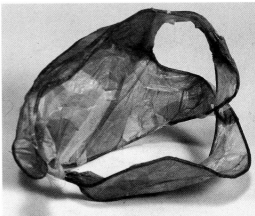

Right
Above Paper construction and drawing.

Below Wire and tissue form.

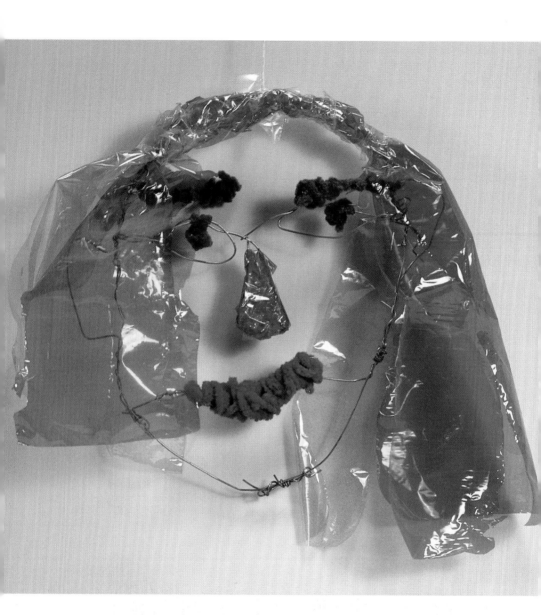

Chris, aged 9, Wire face

Chapter Seven
Using Museums, Galleries and Artists in Residence

The importance of direct experience has been stressed earlier, and there is no doubt that the educational value of exposing children to actual works of art which they can see and touch is immense. There is no real substitute for the immediacy of this visual and tactile experience, and it also provides an opportunity for the children to begin to understand their own and other cultures, and place this understanding in the context of the past. Much of what we know about our own and other societies comes from the artefacts and art objects which we have in our museums and art galleries. These objects, made in a whole variety of materials, provide a unique resource for work across the whole curriculum, and where a visit is convenient for your school the opportunity should be seized.

Planning a visit

There has been a steady improvement in many museums and galleries over the years to make their collections more accessible and interesting for young children, and many have appointed education officers to assist in this. There may be worksheets and questionnaires available which will help to provide a focus for the visit and maximise the educational value of the time spent with the particular collection. If not, it is important for the teacher to prepare their own, and in any event, careful overall pre-planning is vital for any visit. With this in mind, there are some questions which need to be considered.

Kenneth Armitage, 'Figure lying on its side', Bronze 1967

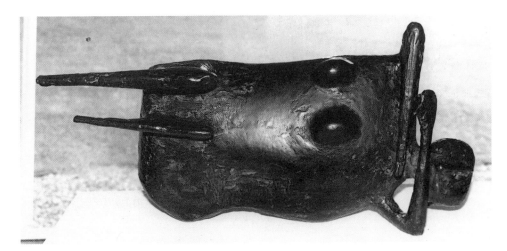

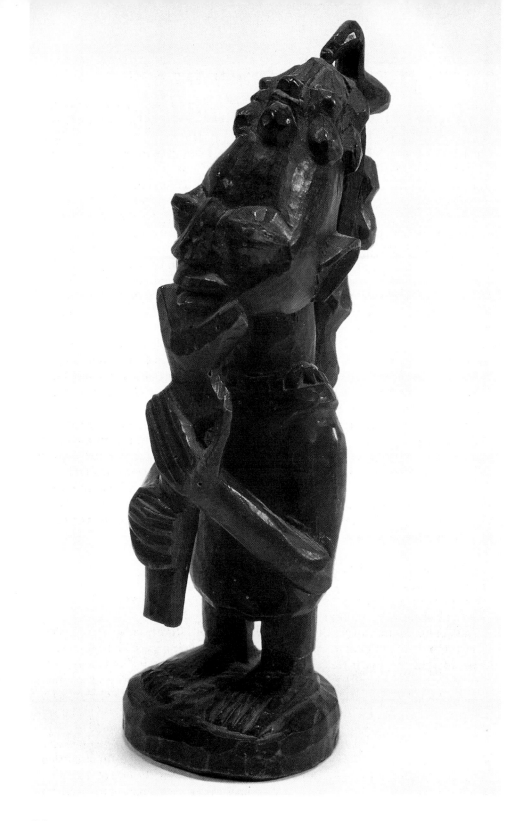

Are the displays easy to see, well lit and with appropriate labels for your children?

Are there particular aspects of the collection which you wish to focus upon?

How will you prepare the children before the visit, and how will you follow it up afterwards back in the classroom?

During the visit there are other questions which the children themselves might need to consider, such as:

What material is the object made from?
How was it made?
What was it used for?
How was it used?
How old is it?
How do you know?
Where was it made/found?.
What similar objects were made before/after your object, and how are they different?
Are there parts of it which you like/dislike, and why?

It may be that there are artefacts which can be handled by the children, and if this is possible you should take full advantage of the opportunity. There is nothing quite like handling work for a complete experience.

Finally, consider whether to encourage the children to draw what they see. It is another important way for them to look closely and to understand and respond to what they are looking at.

Left
Yoruba wood sculpture from Nigeria (collection of the author)

Artists in Residence

There are formal schemes in many areas whereby placements can be organised with artists and craftspeople to work in schools. These can be for short intense periods with a focus on a particular project, say a mural or large sculpture, or it could be over an extended period using say one day a week. Whatever the arrangement or project, the value of having such a visitor is immense. Both children and teachers gain from the additional expertise and insights such practitioners bring to the school, and from the general enrichment in learning.

You might explore whether there is an artist or craftsperson in your area who would be interested in joining you for a placement and give their expertise to your children.

I have already described one such example of a community arts project at the end of the chapter on wood (Chapter 5). What follows is a description of another project in my school where a local artist worked with a class of 10-11 year old children to make an over life-sized figure.

PROJECT 1

The Bilton Giant

This project arose from an opportunity to involve a local artist in the school. There was discussion about the type of work which could be undertaken, and the amount of time and materials likely to be required. It was decided that one class of 10-11 year olds would be involved, and that the work would need to stand inside the school. In discussion with the children, the idea of a giant emerged. He was supposed to have come

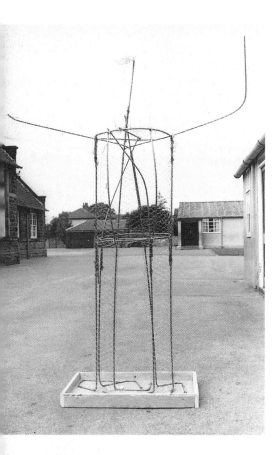

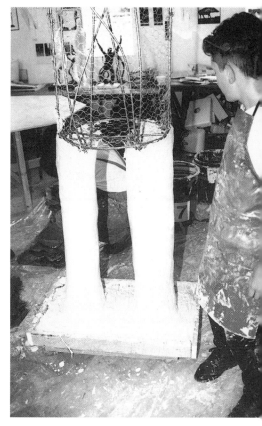

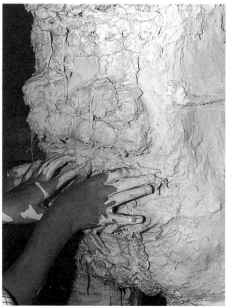

Above, left
Armature of the giant ready to be covered.

Above, right
Starting to cover the armature with plaster soaked hessian.

Left
Adding texture to the front.

Right
Adding strips of hessian to the back.

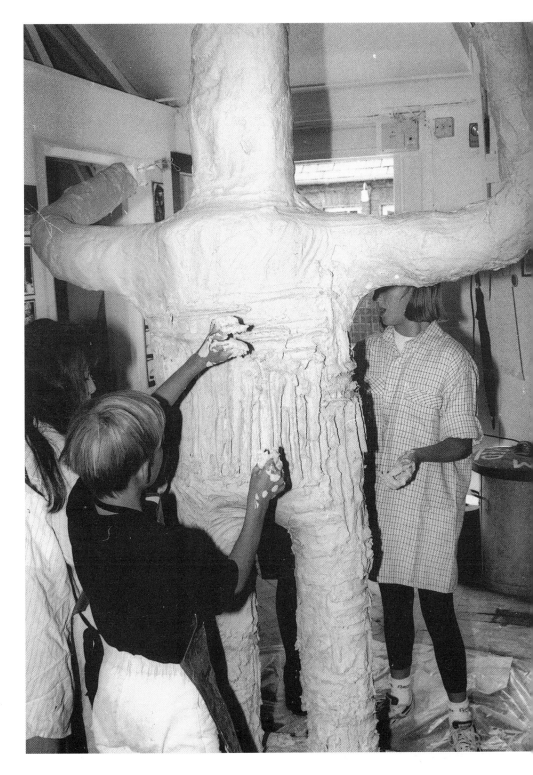

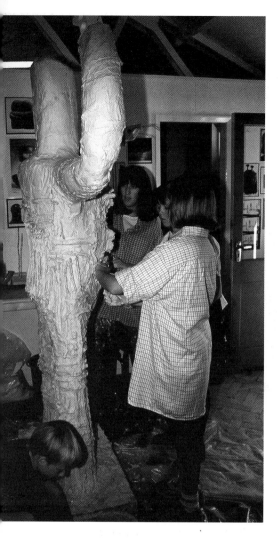

'The Bilton Giant' nearing completion.

on to form the arms and head. This was covered with pieces of wire mesh which were also wired into place. The armature was then placed onto a sheet of plastic to protect the floor from the plaster.

Small buckets of plaster of Paris were then mixed, into which pieces of open weave hessian were soaked and then added onto the wire mesh by the children. This was done starting from the bottom to make the structure more stable. Spare plaster from the buckets was smeared on to the hessian before it set. The children quickly learnt how to mix plaster, and worked in teams cutting the hessian to size and applying it. Approximately two layers of hessian were applied all over, initially, which made a strong and light shell. In order to move the figure around the room it was placed on a wheeled base at this stage.

Smaller strips of hessian, egg boxes and assorted cartons were then used to build up a textured surface by dipping them in plaster and sticking them on. Wire fingers were added on to the hands, and strips of plaster bandage wrapped around to build them up. Because of the height some of the children had to stand on tables to do this, and teamwork became very important. The plaster work took two days to complete, and at the start of the second day the surface was sprayed with water to keep it moist. This was necessary, because if you try to add fresh plaster to a surface which has started to dry, there is a risk of the new plaster flaking off. When it was finished, the whole surface was painted with mixtures of green and brown acrylic paints using a spray gun and large brushes. This provided a stable finished surface suitable for interior display. It was decided early on not to stand it outside because of the risk of frost damage. The whole piece which

from the Nidd Gorge, a nearby deep-wooded river valley which all the children knew, and would need to look as though he lived in this mossy wood. Having decided how the figure should look and stand, and how big it should be, the children worked in rotating groups of 4-5 assisting the sculptor. A substantial armature of thin steel rods was constructed and nailed to a baseboard. Other rods were added by wiring

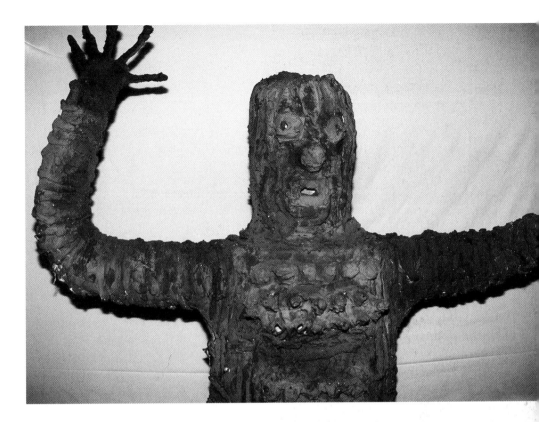

stands almost 7 feet high was completed in about three days, and the class involved gained a great sense of achievement from the experience. The giant has subsequently provided a valuable stimulus for language work with less able children throughout the school. He was named Theo!

Conclusion

It has been my intention with this book to explore some of the ways a variety of three dimensional materials could be used with young children for creative activity, and to suggest how they might be used. These suggestions and examples cannot possibly be exhaustive in this context. Each of the materials covered can be used in other ways and with different starting points to produce

Head and torso after painting.

different results. It is this open-ended potential in relating materials to ideas that makes the whole subject so exciting, and I hope that there will be enough here to encourage both teachers and children to try something new.

It is a function of art and design education to help children to make sense of their experiences (tactile visual, emotional and imaginative etc.) and to challenge their understanding. Through exploring the visual arts they begin to develop a personal language and skills which relate to a whole variety of learning situations, and which are likely to become part of the individuals' vocabulary for life. It is my belief that making, in all its aspects, is an integral part of this learning.

93

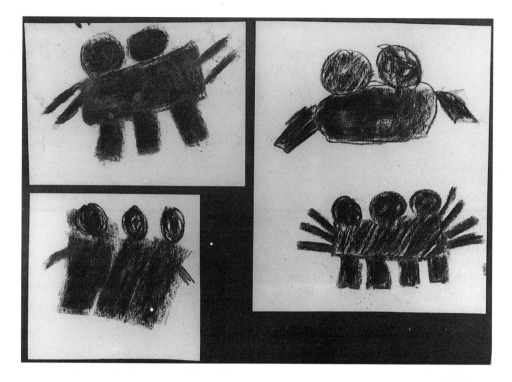

Children aged 10-11, Drawings for sculptures

Bibliography

There is an extensive body of research and information in the fields of both art education and sculpture which relate to this book, and the following provides some initial reference to further reading in these areas. They are not intended to be either prescriptive or exhaustive, but to suggest sources of further information which may assist teachers working with this material.

Background Reading

Jameson, K., *Junior School Art* (Studio Vista,1973)

Jameson, K., *Pre-School and Infant Art*. (Studio Vista,1968)

Lancaster, J. (Ed.), *Art, Craft and Design in the Primary School* (NSEAD, 1986)

Read, H., *Education through Art* (Faber, 1956)

Taylor, Rod, *Educating for Art* (Longman, 1986)

Some specialised books about Sculpture and Sculptural materials

Clough, P., *Clay in the Primary School* (A&C Black,1996)

Fraser, H., *Ceramic Faults and their Remedies* (A&C Black, 1986)

Hamer, F. and J., *Clays*. (Pitman,1977)

Hamer, F.,*The Potter's Dictionary* (A&C Black, 1986)

Nigrosh, L., *Low Fire* (Davis Publications Inc.,1980)

Nigrosh, L., *Sculpting Clay* (Davis Publications, Inc.,1992)

Perryman, J., *Smoke-fired pottery* (A&C Black, 1995)

Sapiro, Maurice, *Handbuilding Clay* (Davis Publications Inc., 1979)

Topal, C.W., *Children, Clay and Sculpture* (Davis Publications, Inc., 1983)

Wondrausch, M., *Mary Wondrausch on Slipware* (A&C Black, 1986)

Index